Prayerful

IRELAND

Helena Connolly

Published by Messenger Publications, 2018

Text and Photographs Copyright © Helena Connolly, 2018

Permission for Clonmacnoise and Glendalough photographs: Office of Public Works (OPW), Heritage Sites.
Permission for Emo Court photograph: Office of Public Works (OPW), Historic Sites.

Every effort has been made to trace copyright holders and to obtain their permission for the use of copyright material. The publisher apologises for any errors or omissions in the above list and would be grateful if notified of any corrections that should be incorporated in future reprints or editions of this book.

ISBN 978 1 78812 012 8

Designed by Messenger Publications Design Department
Typeset in Granjon LT
Printed by Hussar Books

Messenger Publications,
37 Lower Leeson Street, Dublin D02 W938
www.messenger.ie

This book is dedicated to the memory of
Fr Frank Browne SJ (1880-1960).
These photographs are a continuation of his life's mission,
perhaps what he might have photographed if he were still alive today.
Fr Browne's bringing together of faith and photography
is what inspired me to write this book.

Helena Connolly, from Lisnaskea, County Fermanagh, is a professional photographer. She worked for a while as teacher of music and as school chaplain, and was subsequently employed as pastoral worker in the Diocese of Kerry and coordinator of youth ministry in the Diocese of Clogher. Helena is now a parish missioner with the Redemptorist Mission Teams in Limerick. She is also a singer, songwriter and musician, having released two albums, most notably her self-penned album, The Reason Why.

www.helenaconnolly.com

FOREWORD

IRELAND is a country rooted in faith. Our Christian heritage can be traced far back into our history, and it has made us who we are. Much of our character has been formed and shaped by this intangible spirit that has enlivened us for fifteen hundred years. Our ancestors lived and practised their faith in ways that were special to them, and there are many echoes of these practices in the traditions that still live on today in many places. More tangible reminders remain as well. Remnants of ancient churches and old graveyards are scattered throughout our land. Magnificent crosses are found side by side with holy wells and pilgrim paths. They tell us who we are and where we have come from. They may also be pointers to a new way of living our faith in a changing world.

Ireland has changed dramatically in recent decades, and the Church has found itself in an unsettling time of transition. Sunday Mass and sacramental life continue as before, of course, but in reality most parishes are struggling in one way or another. We have an ageing clergy and a largely disaffected youth. Many people have simply 'tuned out' the religious wavelength, and get on with the daily chores as best they can. Pockets of strong faith remain, but the task of handing on that faith to a new generation is proving more and more difficult in the absence of supportive structures and cultural underpinning. It is no longer obvious how to bring God's Word alive in our communities or how to make the life, death and resurrection of Jesus tangible among us. God and the Good News of Jesus Christ have been largely hidden away, reduced to private concerns and personal preferences.

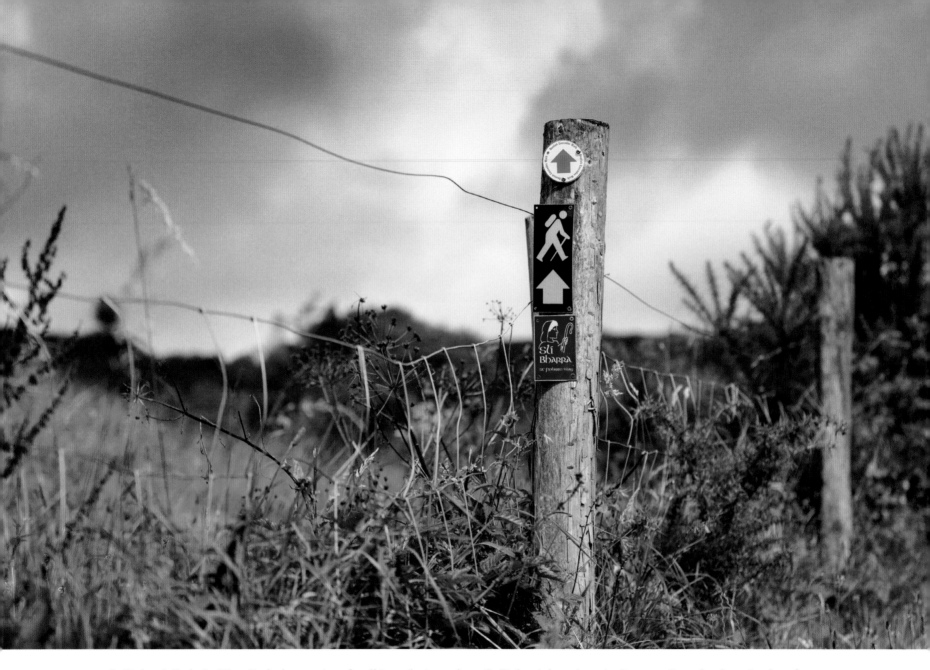

St Finbarr's Path. In West Cork the practice of walking pilgrim paths to St Finbarr's hermitage in Gougane Barra has been in place for many centuries. Opposite Page: A pilgrim sign.

Indeed, Ireland has been so busy becoming a secular country that we have forgotten the sacredness that permeates our island. There is beauty and mystery within its very landscape, which the early monks celebrated so marvellously in their poetry. Indeed, the wonder of our landscape can hardly escape the notice of anyone who takes the time to look, and it is my hope that the photographs in this book will inspire readers to look for themselves at our beautiful land. The recent rediscovery of pilgrim paths across Kerry, Waterford, Wicklow, Cork, Tipperary, Offaly, Mayo, Clare and Donegal has brought with it a reawakening of our Christian heritage in all its richness. In retracing the steps of those who walked before us we may, perhaps, find that the ancient pathways of our forebears can be our pathways as well. Maybe we will find that the way forward into the new Ireland is best found by remaining true to our deepest roots.

We are caught between two worlds. My hope is that the photographs in this book can be a bridge between these two worlds.

Helena Connolly

CONTENTS

Roots of our
FAITH
— 11 —

Treasures of
LIGHT
— 37 —

Traditions of
PRAYER
— 49 —

Praying
TODAY
— 79 —

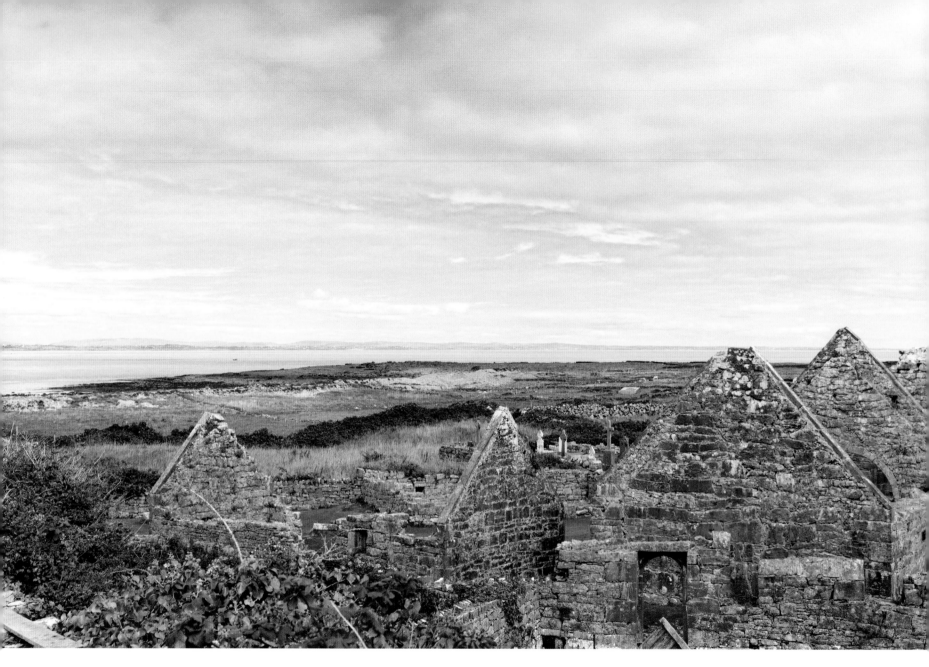

Inishmore Island, County Galway.

Roots of our
FAITH

IRELAND is a country of contrasts. The early Christians came to Ireland around the year AD400 and changed the landscape of the country forever. Traditional pagan beliefs were redefined and Ireland gradually became deeply rooted in the life and teachings of Jesus Christ. Early Christian Ireland saw a huge growth in the monastic tradition and soon there were flourishing communities of faith in many parts of Ireland. Remnants are still evident around the country today, making the roots of our faith real and tangible. Churches, high crosses, graveyards, cells and hermitages are all in different states of preservation; many of them have been restored or replaced over the centuries. People of every part of Ireland have their own story to tell – a land of saints and legend, folklore and tradition, that has one foot in the present and one firmly planted in the past.

Ba sí in chrích fom – themadar eter lissu lann locán álainn eladglan, os mé m'óenur ann.
Let the place which shelters me amid monastic enclosures be a delightful hermit's plot
hallowed by religious stones, with me alone therein.[1]

1. From a ninth century monastic poem. *Early Irish Lyrics 8th to 12th Century*, edited with translation, notes and glossary by Gerard Murphy (Oxford: Oxford University Press, 1956).

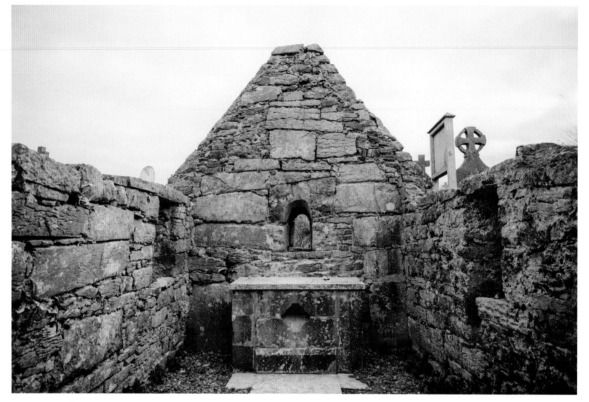

Teaghlach Éinde, Inishmore, County Galway. This church, dedicated to St Enda, dates from the eighth century.

Éanna – or Enda – was a sixth-century saint who chose the island of Inishmore in County Galway for his monastery. This small island was home to a large number of saints, contributing to Ireland's renown as 'the land of saints and scholars'.

You are built upon the foundation of the apostles and prophets, with Christ Jesus himself as the cornerstone. In him the whole structure is joined together and grows into a holy temple in the Lord; in whom you also are built together spiritually into a dwelling place for God. (Eph 2: 20–22)

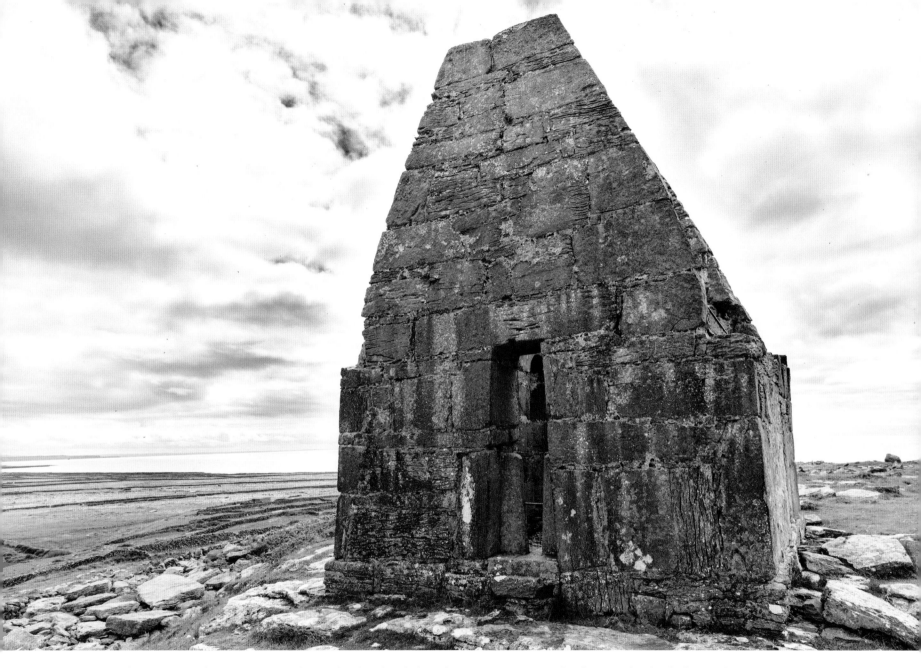

Teampall Bheanáin, Inishmore, County Galway. This church is dedicated to St Beanán, an apostle of St Patrick, who died around AD468.

CLONMACNOISE *County Offaly*

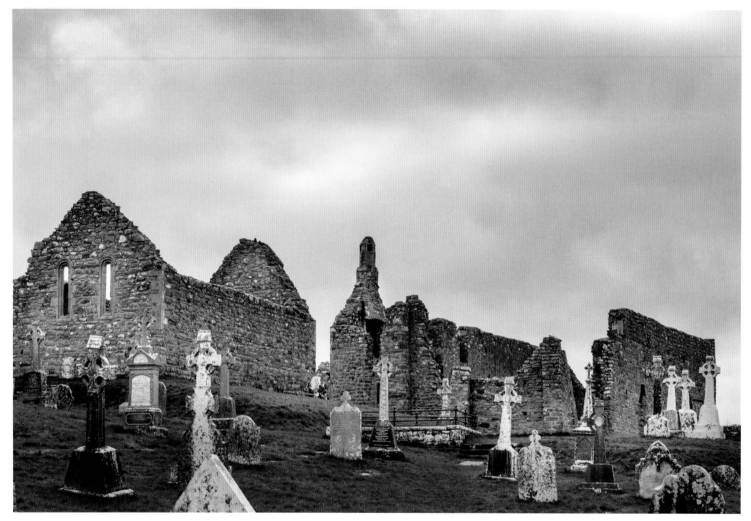

Monastic Site, Clonmacnoise, County Offaly.

All Scripture is inspired by God and is useful for teaching, for reproof, for correction, for righteousness, so that everyone who belongs to God may be proficient, equipped for every good work. (2 Tim 3: 16–17)

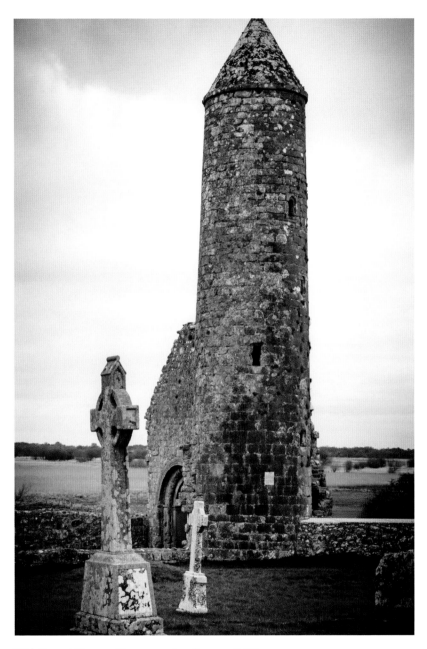

Clonmacnoise sits on the banks of the River Shannon. It was one of the most important ecclesiastical centres of learning in Ireland. It was founded by St Ciarán, who had studied under St Enda on Inishmore. Enda advised him to build a monastery in the centre of Ireland, and this inspired Ciarán to make his foundation in this beautiful place in AD545. Although it was attacked many times throughout its history and was eventually reduced to ruins, Clonmacnoise still stands proudly above the Shannon. From its beautiful stonework and architecture to the lasting legacy of St Ciarán and his successors, Clonmacnoise represents a powerful testament to Christian faith in Ireland.

The Round Tower, Clonmacnoise, County Offaly.

Clonmacnoise, County Offaly.

High Cross, Clonmacnoise, County Offaly.

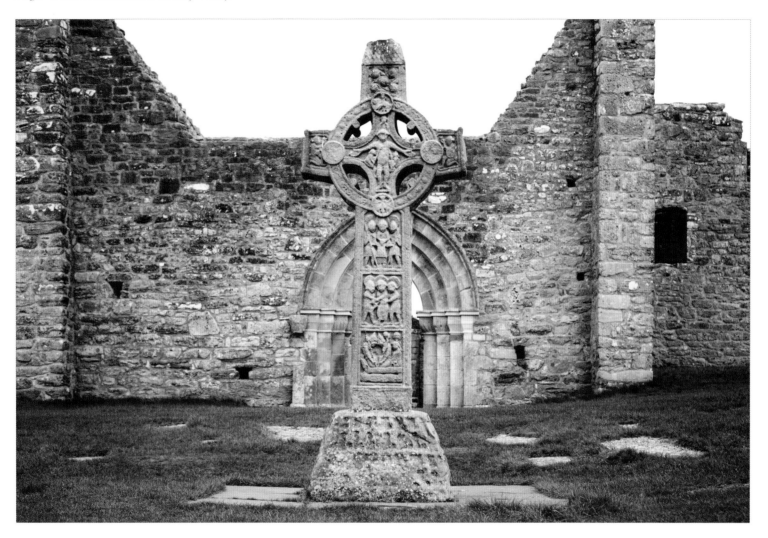

Let us not grow weary in doing
what is right, for we will reap at
harvest time if we do not give up.

(Gal 6: 9)

GLENDALOUGH *County Wicklow*

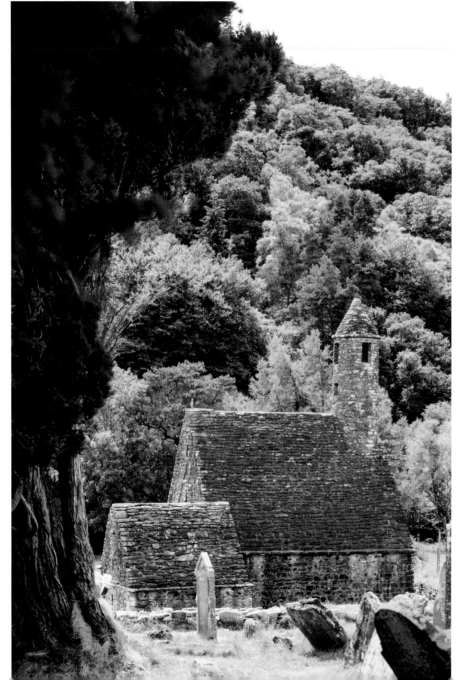

*Those of steadfast mind
you keep in peace,
in peace because they
trust in you.*
(Is 26: 3)

St Kevin founded a monastery in Glendalough in
the sixth century. He came to this inspiring place to
live a life of prayer in communion with God. His
original cell overlooks the lake and is hidden among
the trees and rocks. It is a place of peace, amidst the
beautiful countryside.

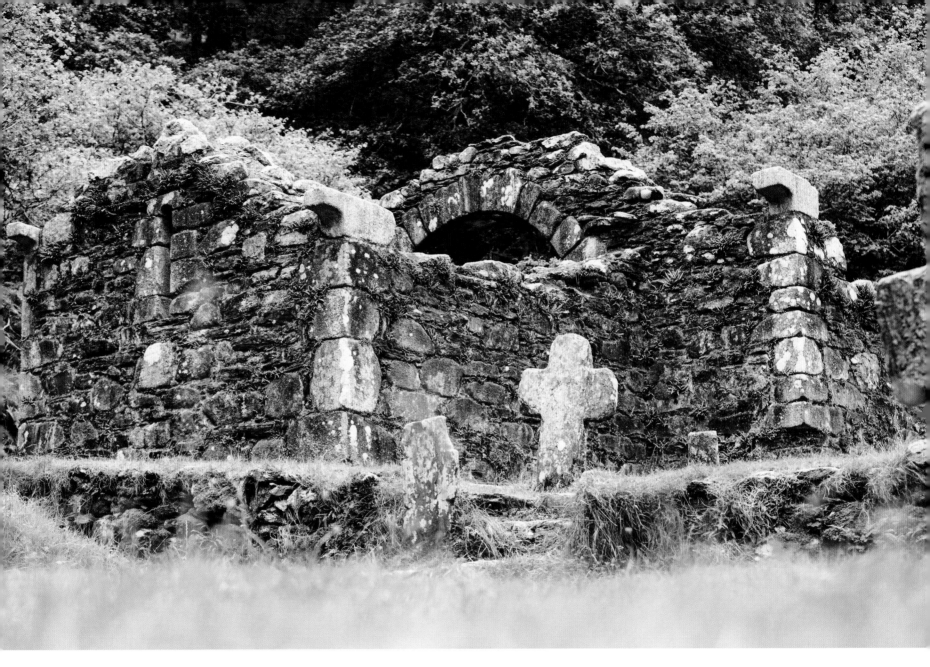

Reefert Ruins and Cemetery, Glendalough, County Wicklow.

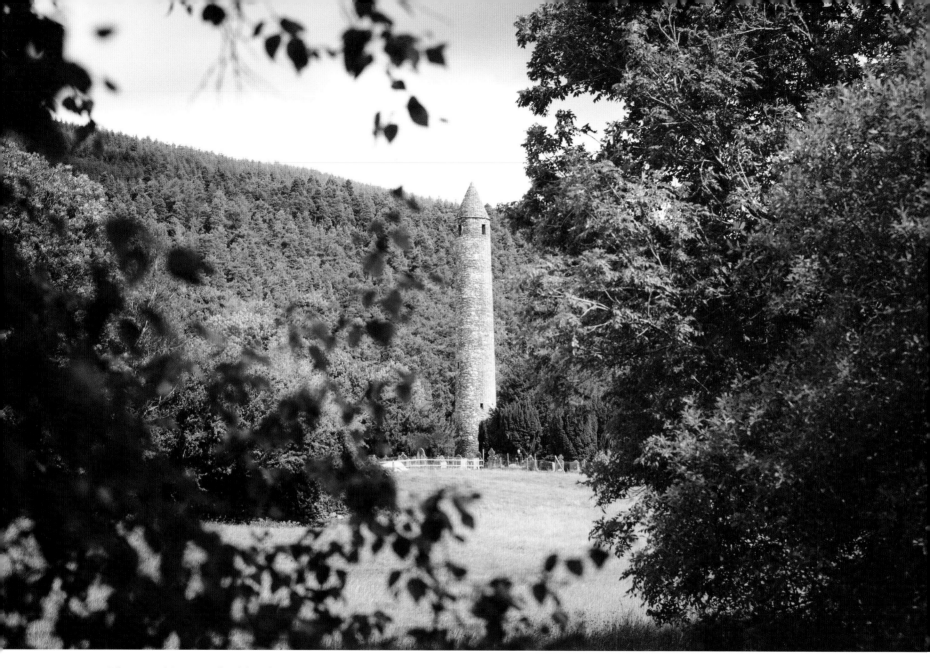

The Round Tower, Glendalough, County Wicklow.

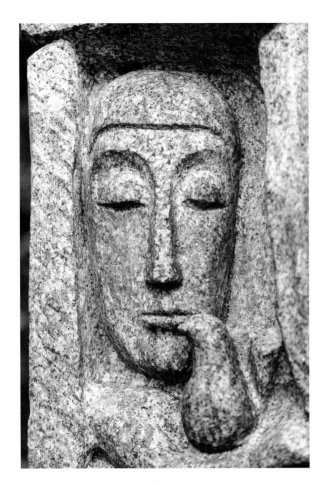

St Kevin and the Blackbird.

Comad Manchín Léith in so

Grant me, sweet Christ, the grace to find – Son of the Living God! –
A small hut in a lonesome spot to make it my abode.
A little pool but very clear to stand beside the place,
Where all men's sins are washed away by sanctifying grace.
A pleasant woodland all about, to shield it from the wind,
And make a home for singing birds before it and behind.
A southern aspect for the heat, a stream along its foot,
A smooth green lawn with rich topsoil propitious to all fruit.

My choice of men to live with me and pray to God as well;
Quiet men of humble mind, their number I shall tell.
Four files of three or three of four; to give the psalter forth;
Six to pray by south church wall
And six along the north.
Two by two my dozen friends – to tell the number right –
Praying with me to move the King who gives the sun its light.

A lovely church, fit home for God,
Bedecked with linen fine,
Where over the white gospel page, the gospel candles shine
A little house where all may dwell and body's care be sought
Where none shows lust or arrogance, none thinks an evil thought.

And all I ask of housekeeping I get and pay no fees:
Leeks from the garden, poultry, game, salmon and trout and bees.
My share of clothing and of food, from the King of fairest face,
And I to sit at times alone and pray in every place.[2]

2. A poem ascribed to Abbot Manchín Léith who died in AD665 but probably dating from the ninth century. It echoes the sentiments of thousands of Irish monks. Translated from the Old Irish by Frank O'Connor. *A Book of Ireland*, ed. Frank O'Connor (Glasgow: William Collins, 1959).

MÁMÉAN *County Galway*

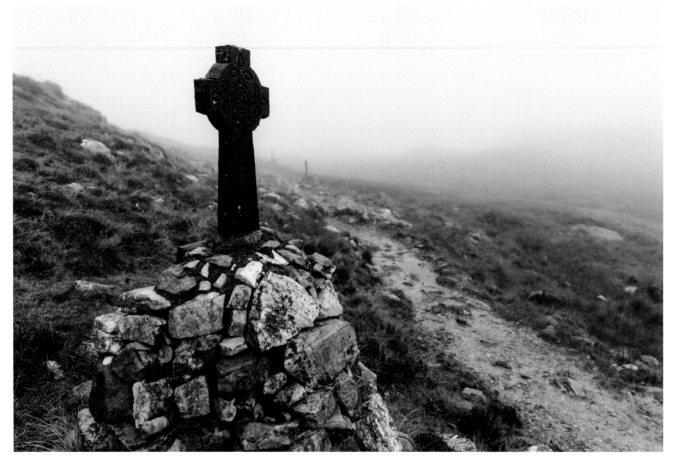

Cross at Máméan, County Galway.

Máméan, in Connemara, County Galway, is the place where, according to legend, St Patrick climbed the mountain and gave Connemara his blessing. It is the site of a Mass rock. In recent years a church, an altar and a statue of St Patrick have been erected.

Therefore, my beloved, be steadfast, immovable, always excelling in the work of the Lord, because you know that in the Lord, your labour is not in vain. (1 Cor 15: 58)

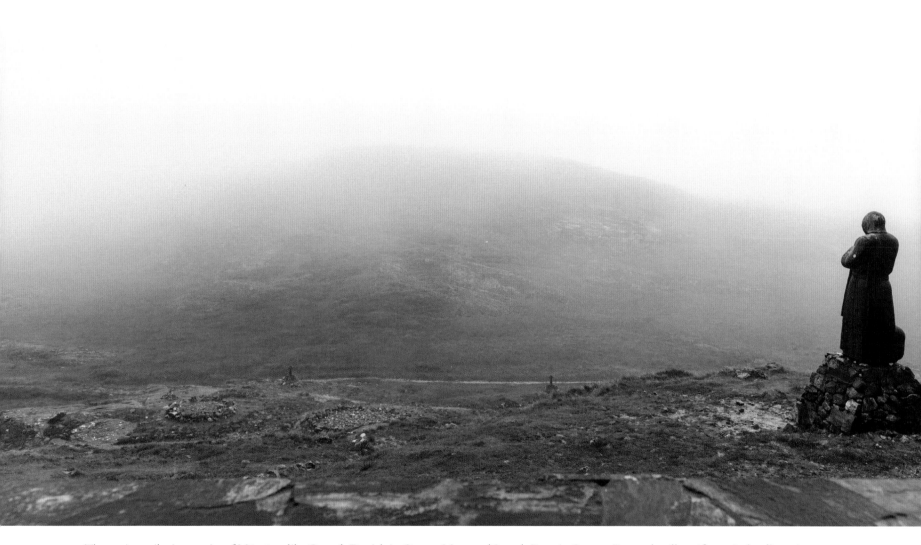

The ancient pilgrimage site of Máméan, like Croagh Patrick in County Mayo and Lough Derg in County Donegal, still testifies to Ireland's ancient devotion to its patron saint, Patrick.

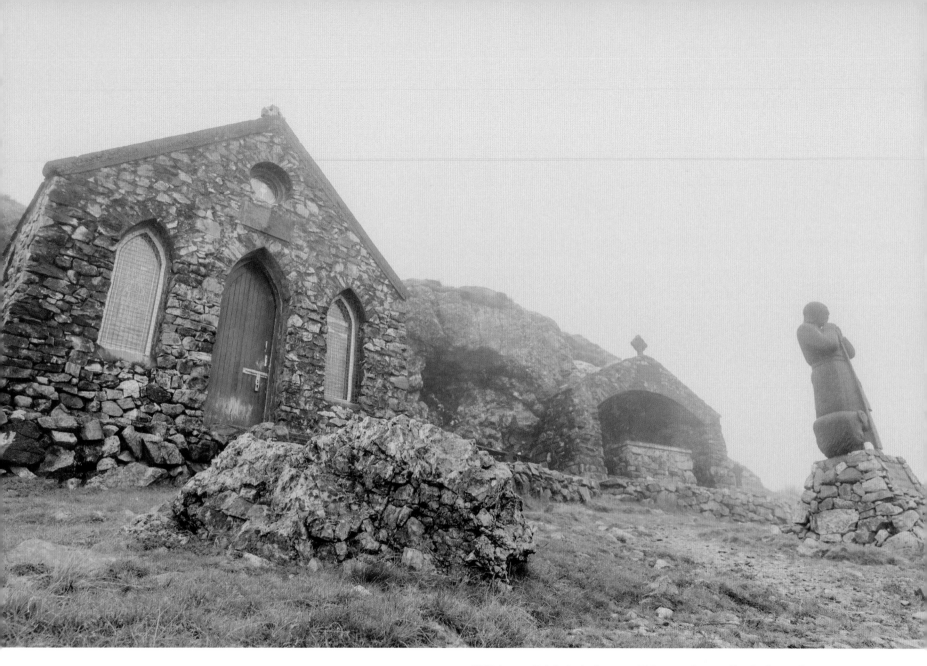

Mámeán chapel and altar.

Without faith it is impossible to please God, for whoever
would approach him must believe that he exists and
that he rewards those who seek him. (Heb 11:6)

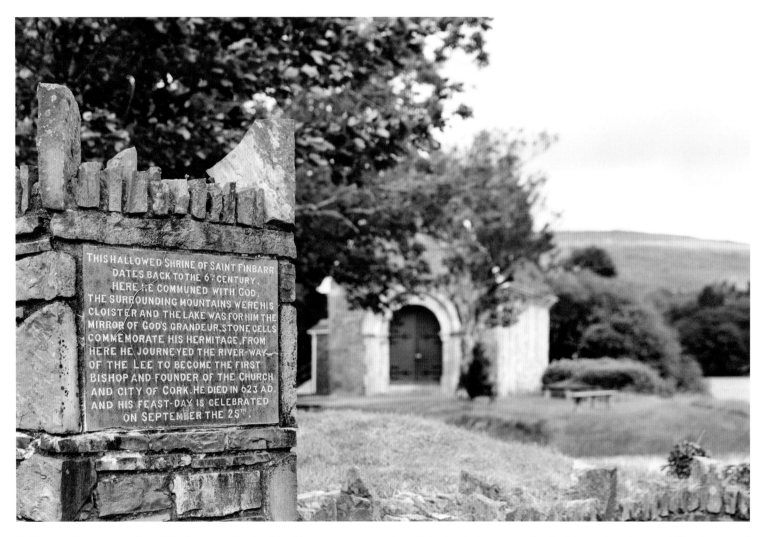

THIS HALLOWED SHRINE OF SAINT FINBARR
DATES BACK TO THE 6TH CENTURY.
HERE HE COMMUNED WITH GOD.
THE SURROUNDING MOUNTAINS WERE HIS
CLOISTER AND THE LAKE WAS FOR HIM THE
MIRROR OF GOD'S GRANDEUR, STONE CELLS
COMMEMORATE HIS HERMITAGE. FROM
HERE HE JOURNEYED THE RIVER-WAY
OF THE LEE TO BECOME THE FIRST
BISHOP AND FOUNDER OF THE CHURCH
AND CITY OF CORK. HE DIED IN 623 A.D.
AND HIS FEAST-DAY IS CELEBRATED
ON SEPTEMBER THE 25TH.

St Finbarr, the patron saint of Cork, reputedly lived in this remote spot as a hermit in the sixth century. As disciples gathered around him, he moved to what is now Cork City, where his monastery became a renowned centre of learning.

A Hermit's Song

My heart stirs quietly now to think
of a small hut that no one visits
in which I will travel to death in silence.

Hardly a mile from this pleasant clearing
is a bright spring to drink from and use
for moistening measured pieces of bread.

For all my renouncing and sparse diet
and regular tasks of reading and penance
I foresee only delight in my days there.

The thinness of face and fading of skin,
the pain given by damp and a hard bed
to a frail body, will hardly distress me.

For I look to have frequent visits from birds
and sunlight and Jesus the King who made me,
and my mind will be calling on him each morning.

When I and the things I used are faded,
some men will remember and respect the place
where a man all day prepared his dying.[3]

The Lark

Learned music sings the lark,
I leave my cell to listen;
His open beak spills music, hark!
Where heaven's bright cloudlets glisten.
And so I'll sing my morning psalm,
That God bright heaven may give me,
And keep me in eternal calm,
And from all sin relieve me.

Translation from the Old Irish. *The Irish Tradition*
by Robin Flower (Oxford: Clarendon Press, 1948)

3. Based on an Old Irish monastic poem. Part of 'A Hermit's Song',
version by James Simmons. *The Faber Book of Irish Verse*, ed. John
Montague (London: Faber and Faber, 1974).

KILMALKEDAR *Dingle Peninsula, County Kerry*

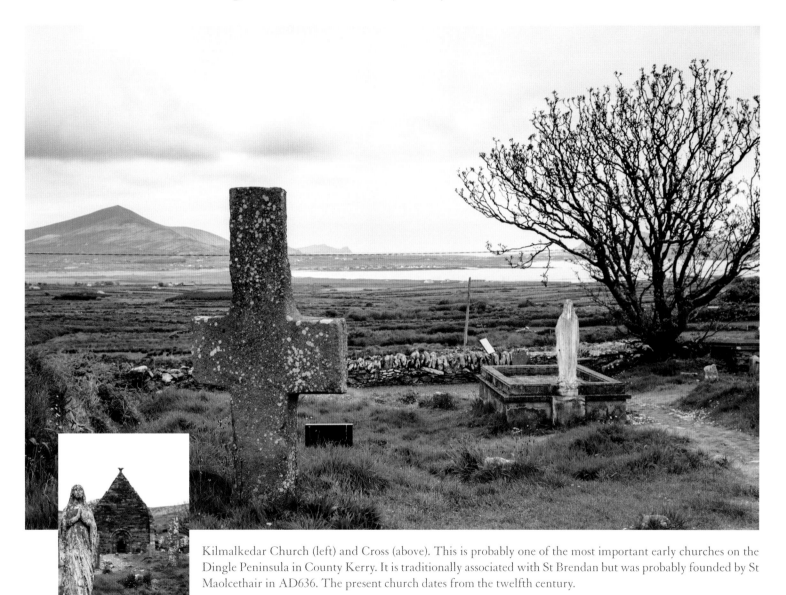

Kilmalkedar Church (left) and Cross (above). This is probably one of the most important early churches on the Dingle Peninsula in County Kerry. It is traditionally associated with St Brendan but was probably founded by St Maolcethair in AD636. The present church dates from the twelfth century.

For God is not unjust he will not overlook your work and the love that
you showed for his sake in serving the saints as you still do. (Heb 6: 10)

ST COLMAN'S HERMITAGE *The Burren, County Clare*

Tuaim Indhir

In *Tuaim Indhir* here I find
No great house such as mortals build,
A hermitage that fits my mind
With sun and moon and starlight filled.

'Twas Gobban shaped it cunningly
– This is a tale that lacks not proof –
And my heart's darling in the sky,
Christ, was the thatcher of its roof.[4]

The Burren landscape, close to St Colman's Hermitage in County Clare.

What we need most in order to make progress is to be silent before this great God with our appetite and with our tongue, for the language he best hears is silent love. St John of the Cross

4. Translation from the Old Irish. *The Irish Tradition* by Robin Flower (Oxford: Clarendon Press, 1948).

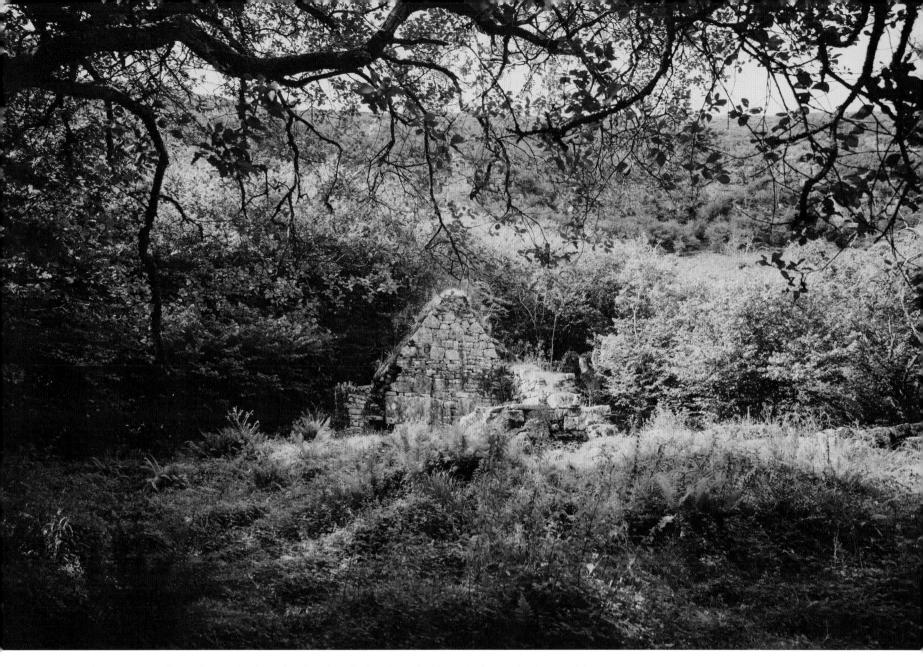

The hermitage of St Colman of Kilmacduagh, where he lived in solitude in the barren landscape of the Burren.

St Colman's Hermitage in County Clare

There is a stillness and quality of silence that exists in the Burren, which perhaps explains why St Colman chose to live and pray here for many years. Everything in the environment is harsh. The rocks stand firm, tough, unrelenting in the face of the elements. The trees bend to the wind and are moulded by its force. Strange flowers barely peep through the fissures in the rock. Here is silence and mystery and beauty.

The monks of Skellig Michael – that great barren rock that rises dramatically from the Atlantic off the coast of Kerry – testify to a similar spirit. Theirs was a life of isolation, devotion and silence, in tune with the landscape and the rocks and the wind, focused in an absolute way on God. However fierce the storm or however mean the soil, God was always present for them, always to be loved, ever to be trusted. Whatever came their way, God was a constant presence and source of strength.

KILMACDUAGH *County Galway*

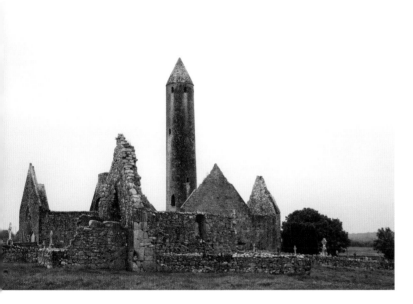

Do not neglect the gift that is in you, which was given to you through prophecy with the laying on of hands by the council of elders. Put these things into practice, devote yourself to them so that you all may see your progress. Pay close attention to yourself and to your teaching; continue in these things for in doing this you will save both yourself and your hearers. (1 Tim 4: 14–16)

The original monastery of Kilmacduagh, near Gort in County Galway, was founded by St Colman, son of Duagh, in the seventh century, but was later totally destroyed. In its place an abbey was built for the Augustinian Canons in the thirteenth century, which itself now lies in ruins. The striking round tower dates from the tenth century.

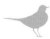

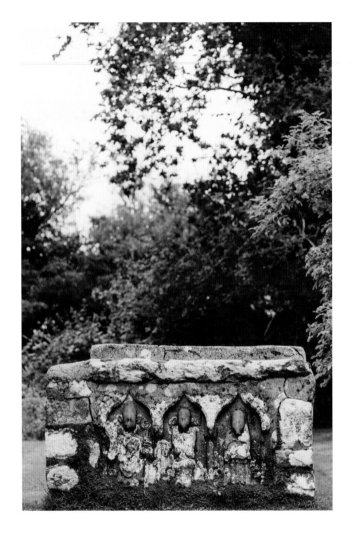

Left: The Stone Altar at Tober na Malt, County Kerry. Three figures are prominent, possibly St Brendan, St Eirc and St Ita. Above: Lisglasson Mass Rock, Clontibret, County Monaghan.

The Mass Rocks around our country are a living testimony to the faith of our ancestors. Humble, unassuming and usually hidden away well out of sight, it must have been awe-inspiring to participate in the Mass in these places at a time when its celebration was forbidden by law. If we have time to listen, we may be able to hear the whispered prayers of the people, the words echoing around the landscape in the still air.

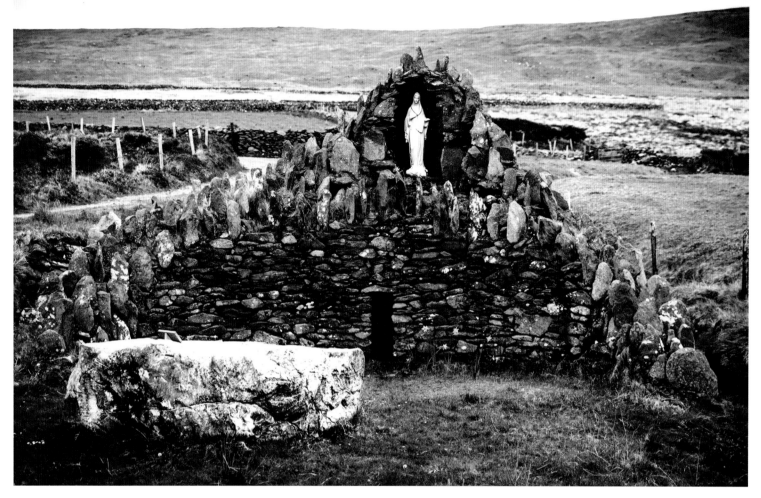

Mass rock and modern grotto at the foot of Mount Brandon, County Kerry.

Sláinte an Ard-Mhic do leag a ghéaga ar chrann na Páise chun sinn a shaoradh,
agus sláinte na mná mánla do rug a Mac gan chéile,
agus sláinte Naomh Pádraig do bheannaigh Éire.[5]

Health to the noble Son who spread his arms on the tree of the passion to free us,
and health to the gentle woman who without man gave birth to her son,
and health to St Patrick who blessed Ireland.

5. Traditional Prayer, composed when Mass was celebrated at the Mass Rock, to be recited after communion.

ROUND TOWERS *County Kerry*

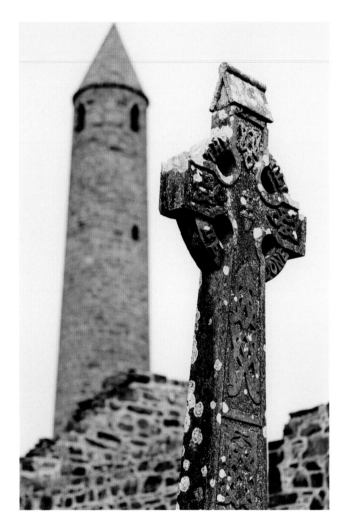

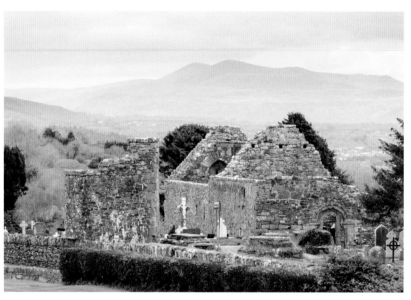

The round towers of Ireland were built, mostly between the ninth and twelfth centuries, in close proximity to a church or monastery. Despite their prominent position in our landscape, there is considerable dispute about their purpose. The Irish name, *cloigtheach*, suggests that they were elaborate bell towers. Other theories suggest that they were watchtowers to guard against enemy attacks, or that they were places where relics and other precious artefacts were kept hidden from the pillaging Vikings. In any event, the towers must have been a beacon of hope for the weary pilgrim whose waning spirits would be lifted by the realisation that their destiny was within reach.

Above and facing page: The round tower of Rattoo Abbey, County Kerry. Above right: The base of the round tower of Aghadoe, County Kerry.

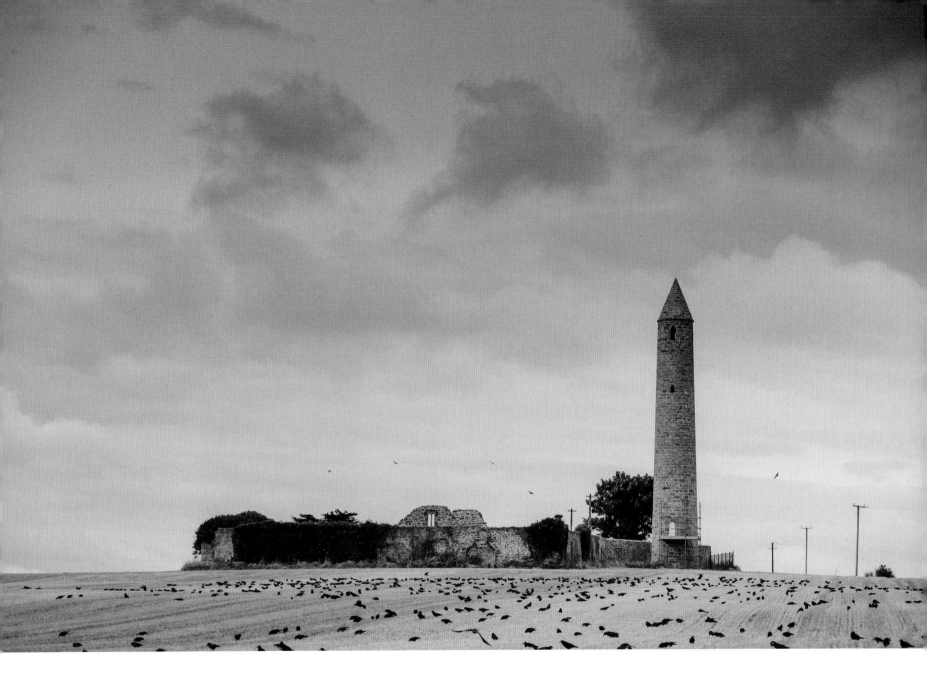

Seek the Lord and his strength, seek his presence continually. (1 Chr 16: 11)

The Cathedral of Our Lady Assumed into Heaven and St Nicholas, Galway City.

Treasures of LIGHT

IRELAND's churches have been of enormous importance for their surrounding communities, bringing the faithful together to celebrate Mass and to pray. They have been a source of comfort and solace in good times and bad, enabling generations of believers to participate in the sacramental life of the Church, and bringing people closer to Jesus in the Blessed Sacrament.

These holy buildings, homes to the great mystery of our faith, frequently contain treasures that reflect that mystery. The power of art in the history of the Church has been well documented. Throughout the centuries, artists have depicted the life of Jesus, the saints and the prophets through sculpture, painting and iconography. Glass has also been a powerful medium in the service of faith in our churches. Stained-glass windows, simply by throwing light and colour into the dark corners of a building, can evoke a sense of wonder and awe, lifting the heart to the mysteries beyond.

Stained-glass windows have much more than the purely decorative function of softening the harshness of stone. They are powerful instruments of prayer. They frequently illustrate stories from the gospels, the Old Testament or the lives of local saints, inviting us to enter into the narratives they depict. Many churches in our country hold within them treasures of light and shade – coloured shapes that can take us into a deeper place, if we only take the time to look, absorb their beauty and listen to the voice of the lord.

The people who sat in darkness have seen a great light,
and for those who sat in the region and shadow of death light has dawned.

(Mt 4: 16)

GALWAY CATHEDRAL *County Galway*

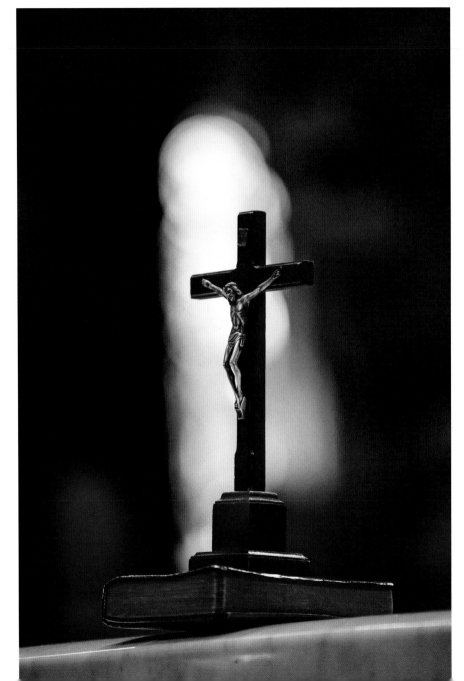

For he will command his
angels concerning you to
guard you in all your ways.
(Ps 91: 11)

Detail from windows in St Joseph's Church, Ballindine, County Mayo.

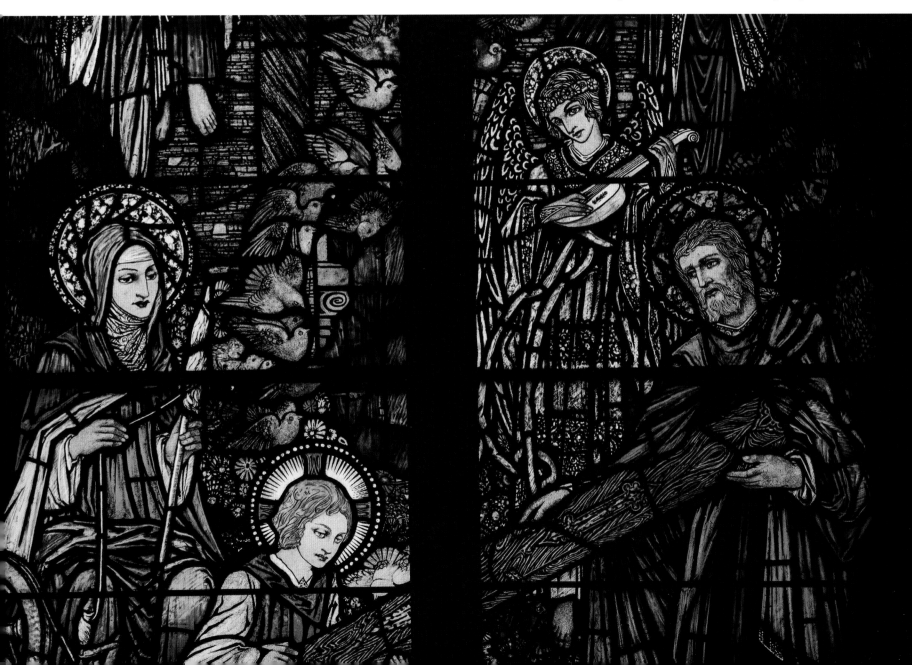

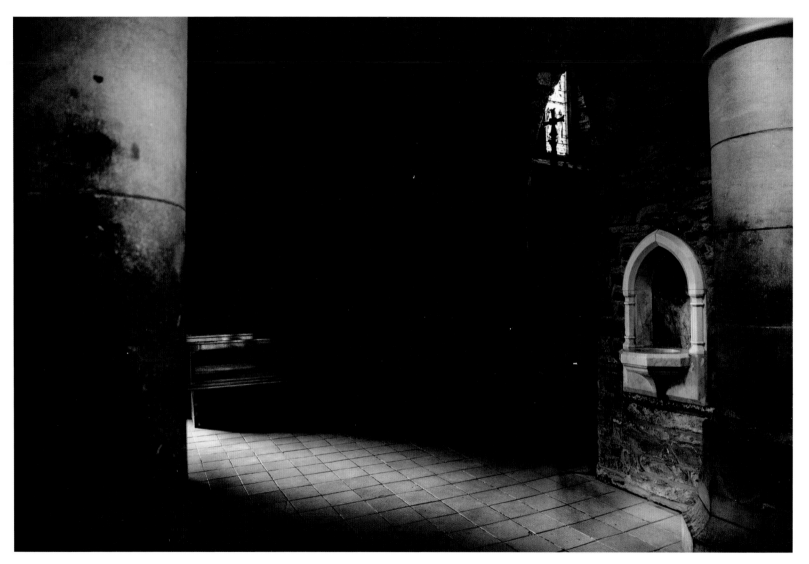

Light leading to the holy water font, St Mary's Cathedral, Killarney, County Kerry.

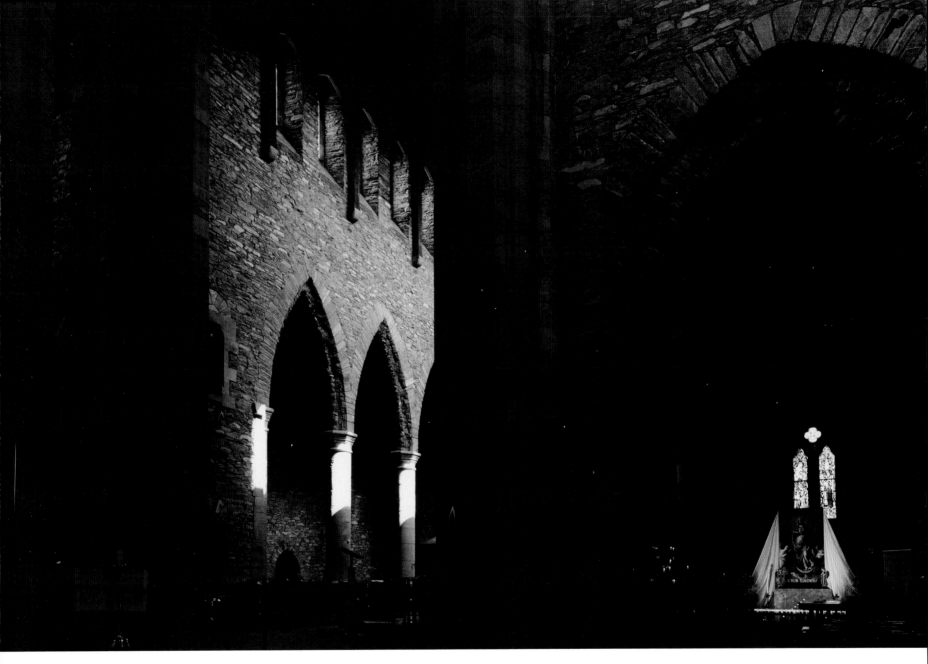

Sacred space in St Mary's Cathedral, Killarney, County Kerry.

ST JOHN'S CHURCH
County Kilkenny

*From the rising of the
sun to its setting, the
name of the Lord is to
be praised. The Lord
is high above all the
nations and his glory
above the heavens.*
(Ps 113: 3–4)

Evening light on Good Friday.

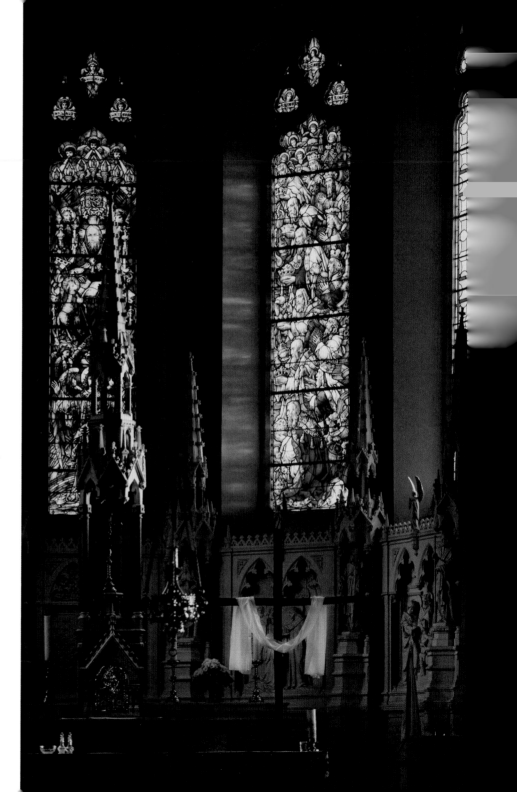

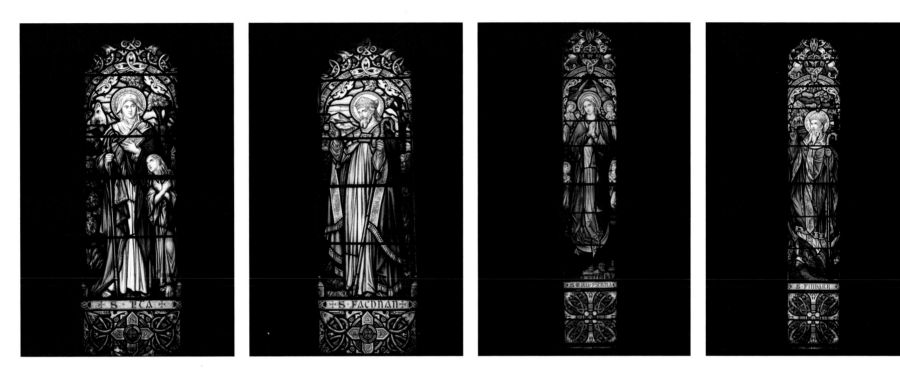

Images of saints venerated locally in the Church of Gougane Barra, Macroom, County Cork: St Ita, St Fachanan, St Maria Patrona and St Finbarr.

*So let us not grow weary in doing what is right, for we will
reap at harvest time, if we do not give up.* (Gal 6: 9)

MANRESA JESUIT CENTRE OF SPIRITUALITY *County Dublin*

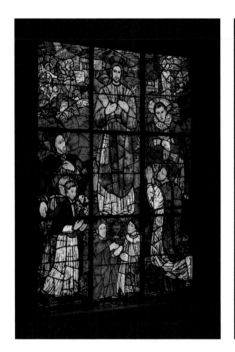 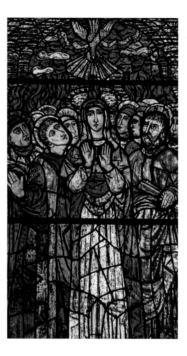 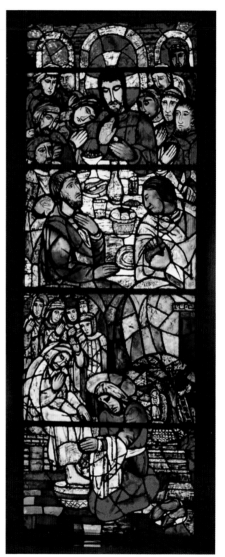

Four images from stained-glass windows by Evie Hone in Manresa, Jesuit Centre of Spirituality, County Dublin. Left to right: The Sacred Heart with some Jesuit saints; The Washing of the Feet; The Descent of the Holy Spirit at Pentecost; The Institution of the Eucharist.

I have set you an example that you should
do as I have done for you. (Jn 13: 15)

AN DÍSEART CHAPEL *Dingle, County Kerry*

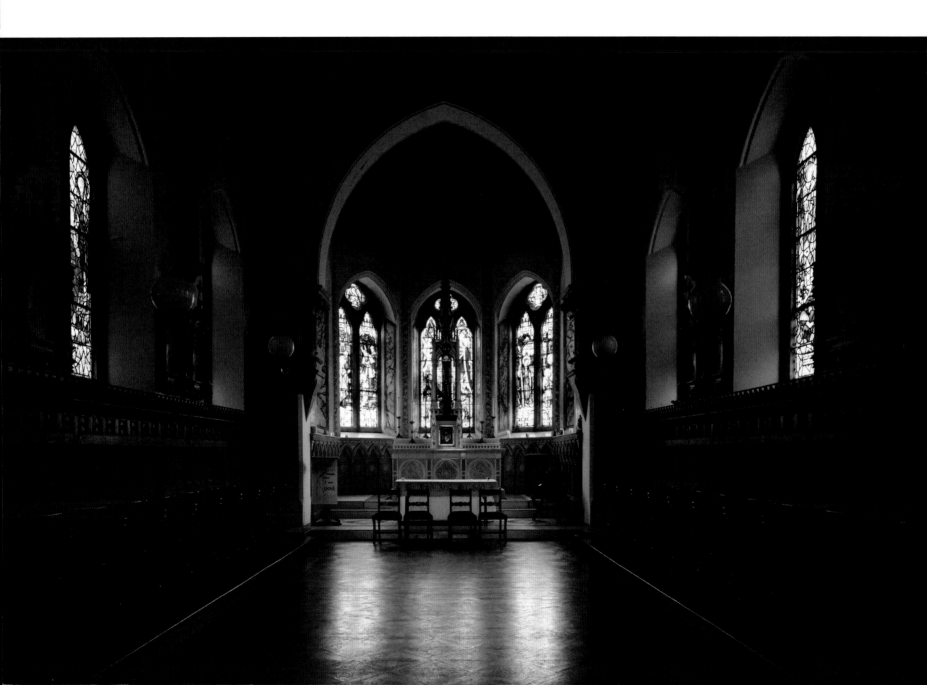

ST COLMAN'S CHURCH *Claremorris, County Mayo*

 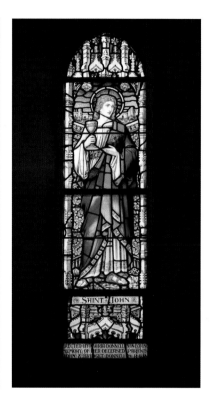

The four gospel writers depicted in St Colman's Church, Claremorris, County Mayo.

Trust in the Lord with all your heart, and
do not rely on your own insight. He will
make straight your paths. (Prov 3: 5–7)

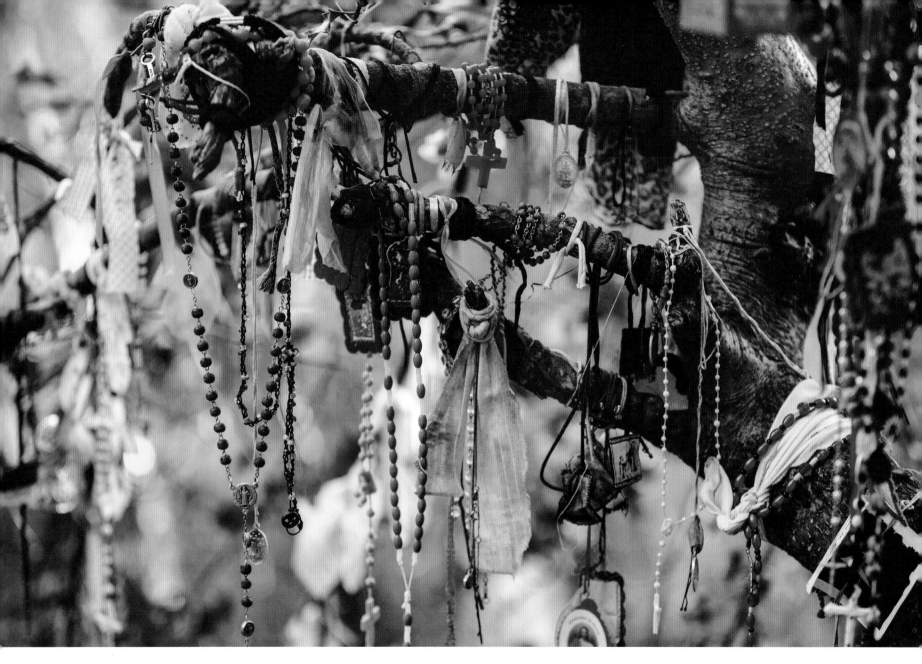

Prayer Tree at Tobarnalt, Holy Well, County Sligo.

Traditions of
PRAYER

I'VE SPENT much of my life on the road. As a musician, photographer and missioner, I have seen a lot of Ireland in the past twelve years. As I drive around, I meet people everywhere, catching a glimpse of the world they inhabit, which I will never really know. As a passing stranger, I only get snapshots of what lies behind the windows and walls, beyond doors and fences. But sometimes a fleeting glimpse is all it takes, because I've come to realise that basically we're all the same.

Life is simple. It involves living out the great gift we have received, moment by moment. As families, we try to care for one another as best we can, making our homes comfortable and keeping our children safe, while trying to make ends meet. We fail, of course, but something prompts us to keep going and try again.

All of us are united by the time in which we live and the space we inhabit. We are united by the past that formed us and by the hopes we have for the future. We have many bonds in common that are deep and real but are usually well hidden from sight.

The prayer trees that are scattered around our country are visible signs of our common journey. Many times, sitting at the roots of one of these trees, I am reminded of how we are all united in spirit: old and young, men and women, sick and healthy. The prayers that hang as rags on the branches are snapshots of people's lives: their hopes and fears, their joys and sorrows, their gratitude and pain. They speak of untold stories, deep secrets, joys and hopes, illness, grief and loss. In places like these, you get a sense of the prayers that are in all of our hearts.

All of you, have unity of spirit, sympathy, love for one another,
a tender heart, and a humble mind.
(1 Pt 3: 8)

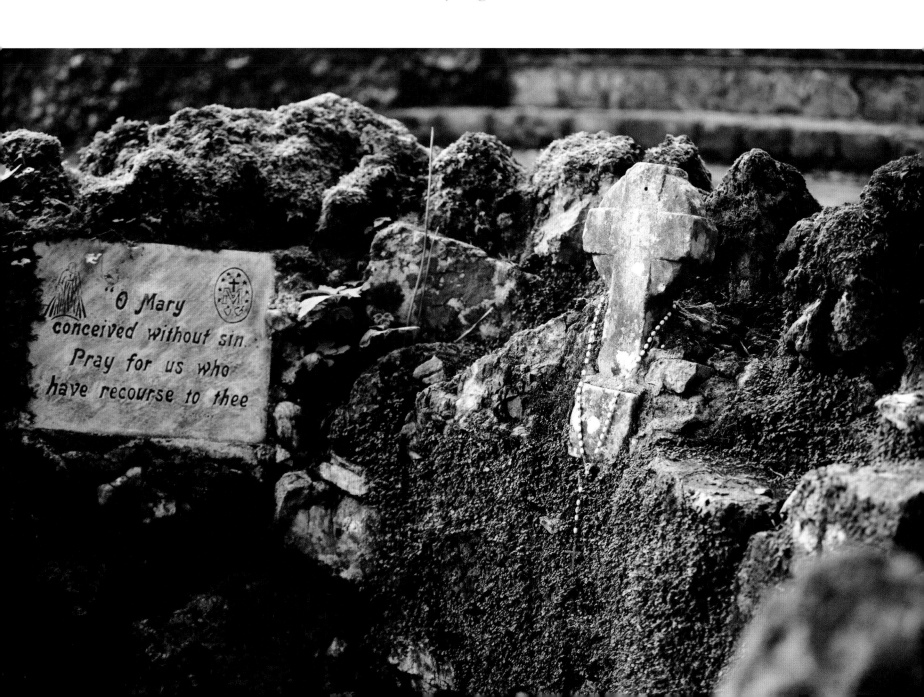

Loving God

Loving God, I leave a little of myself here today.
All I have is an old rag that I've owned
for as long as I can remember,
yet today it is more than a rag.
Today, it is a heartfelt prayer from deep within myself.
It is humble, dirty, long unused,
and yet I know that you take this rag
and look upon it with the utmost love.
Today this rag is me.
Today I tie it here to this branch in this place
alongside other rags –
perhaps their pain as raw as mine.
Take my prayer and my tattered offering this day,
 Lord.
When winter comes,
may my prayer remain when this tree is bare.
In the unfolding of nature's cycles
may my faith grow in abundance like the shoots of
 spring.
May I return again to discover the growth that has
 happened within me:
the pain that has softened, the smile that has returned,
the promised redemption.
I leave a little of myself here with you, Lord.
Today this rag is me.
Look upon me with your loving care.
Amen.

Tobarnalt, by the shores of Lough
Gill, County Sligo.

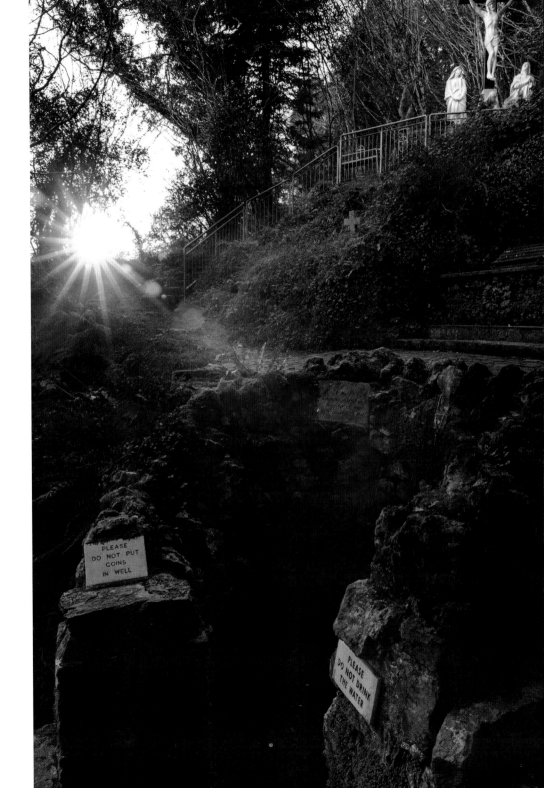

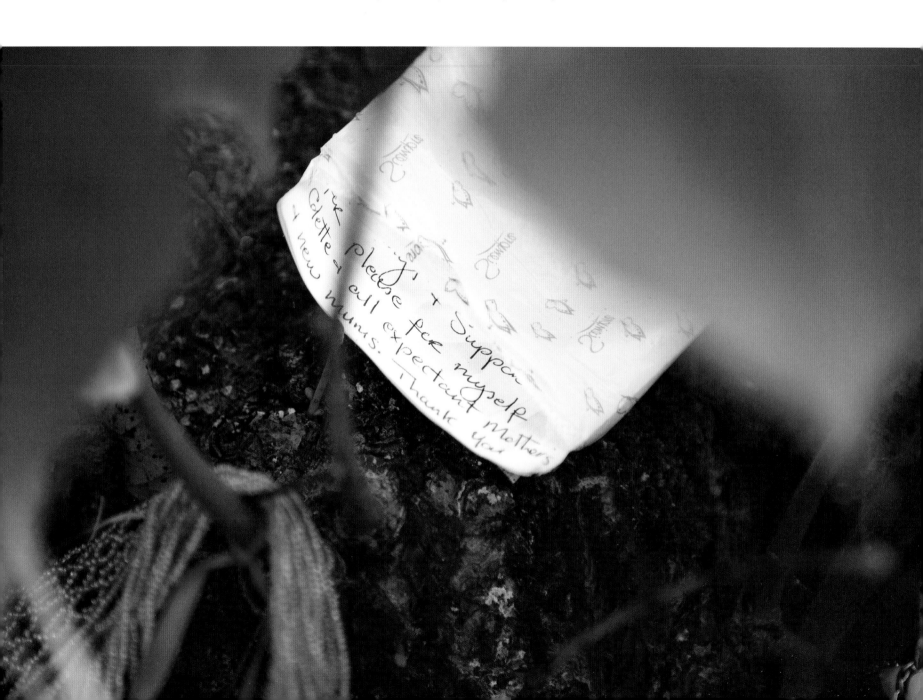

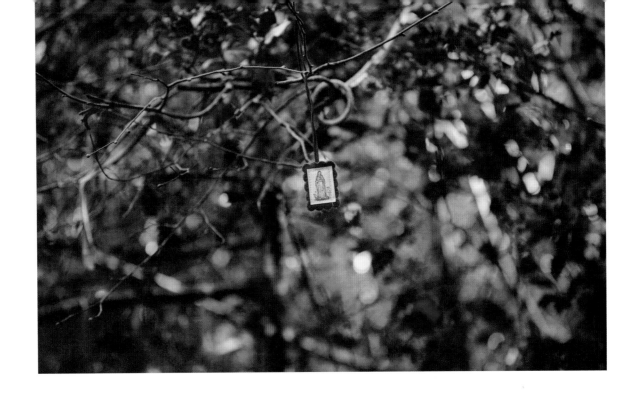

Left and right:
prayer trees at
St Gobnait's Well,
Ballyvourney, County
Cork with rags and
notes and relics.

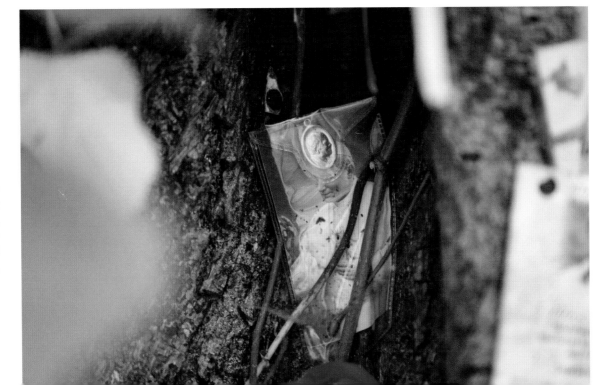

The wise prevail through great power, and those who have knowledge get stronger and stronger.

(Prov 24:5)

Legend has it that St Gobnait, while living on Inis Oírr, the smallest of the Aran Islands, was directed by an angel to found a convent in a place where there were nine white deer. Having found the nine deer at a site overlooking Baile Bhúirne, she established a foundation at this spot. Inis Oírr, Baile Bhúirne and Dún Chaoin in west Kerry are still centres of devotion to St Gobnait.

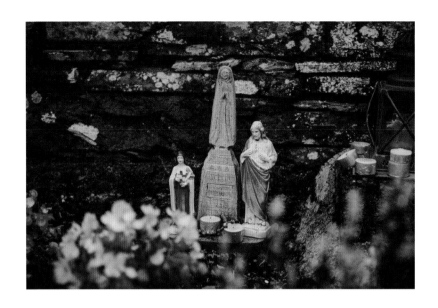

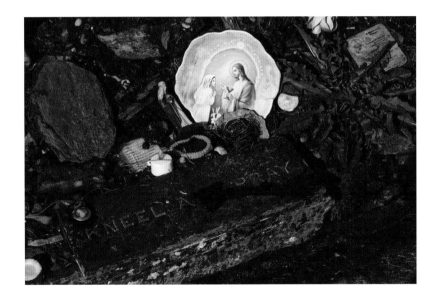

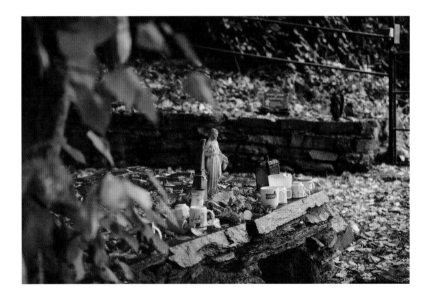

Heal me, Lord, and I will be healed; save me and I will be saved, for you are the one I praise.

(Jer 17:14)

There are over 3,000 holy wells in Ireland, a visual testament to the significance our people attributed to the gift of water. For many, these wells have become nostalgic reminders of an earlier Ireland, a unique part of our identity and culture that hasn't yet succumbed to ruthless modernisation. Some of our country's holy wells, indeed, have been neglected with the passing of time, and many have probably been forgotten. Nevertheless, there are many others throughout the country where local people still come to pray, to remember, perhaps just to linger.

Frequently statues, broken ceramics, items of clothing and coins can be found strewn around these wells, symbols of people's hopes and prayers. In some communities, the upkeep of these wells is entrusted to a few faithful parishioners, who ensure that they are kept clean and fresh as life-giving centres of faith. In other places, great numbers are still drawn to these wells on 'pattern' or 'patron' days, when Mass is celebrated and prayers and rituals observed in memory of the associated saint.

Perhaps, in our time, we will learn to treasure more fully these ancient reminders of our faith, in gratitude to those who prayed there before us and as gifts to pass on to generations yet to come.

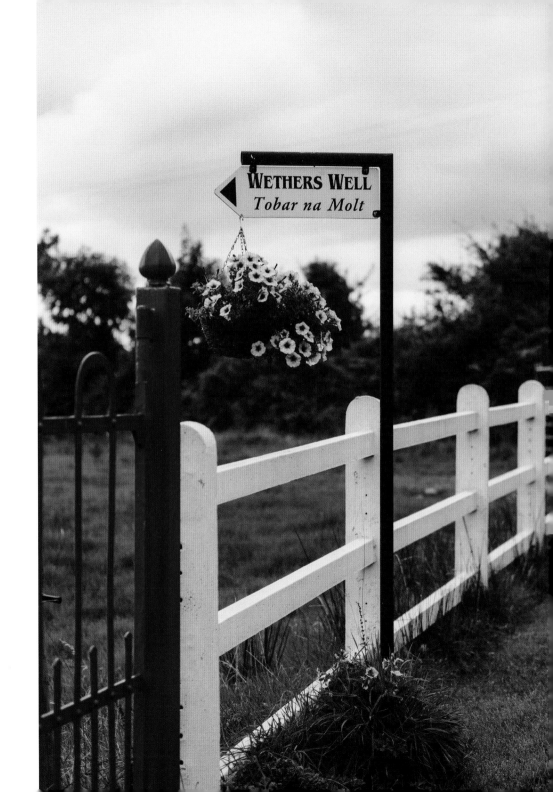

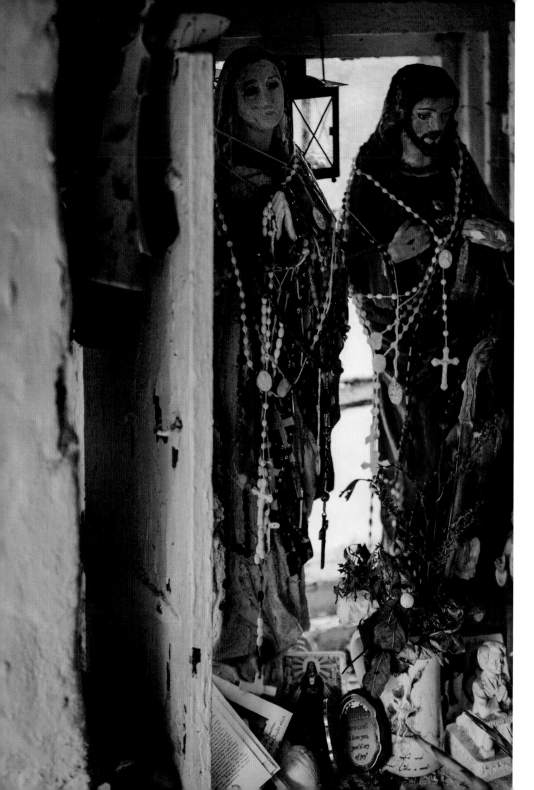

Do not worry about anything, but in everything by prayer and supplication with thanksgiving let your requests be made known to God. And the peace of God, which surpasses all understanding, will guard your hearts and your minds in Christ Jesus.

(Phil 4: 6–7)

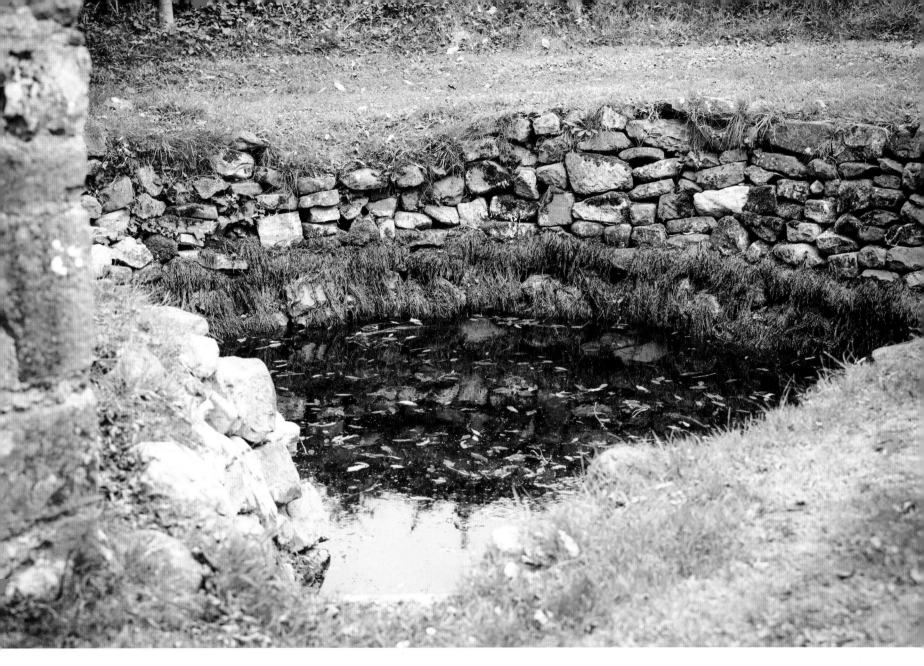

Above, Wethers Well and, facing page, evidence of petitions and prayers

Why are you cast down, O my soul, and why are you disquieted within me?
Hope in God; for I shall again praise him, my help and my God. (Ps 42:5–6)

ST PATRICK'S WELL *Ballintubber, County Mayo*

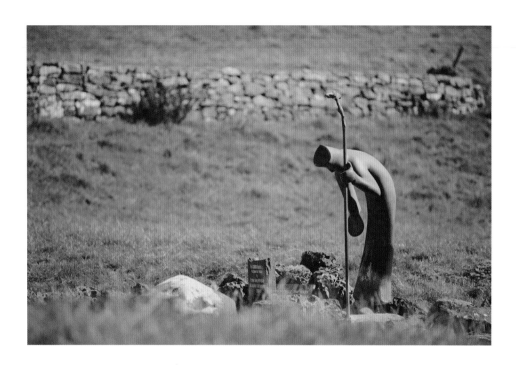

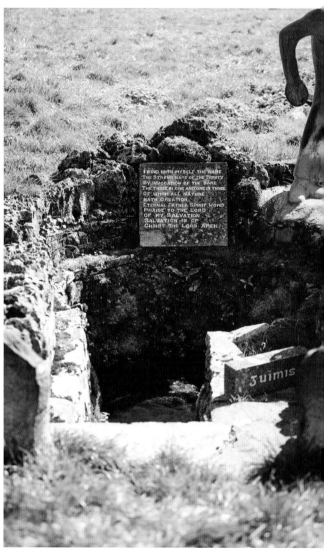

He said, 'Go, therefore, make disciples of all nations; baptise them in the name of the Father and of the Son and of the Holy Spirit. (Mt 28:19)

ST PATRICK'S WELL *Belcoo, County Fermanagh*

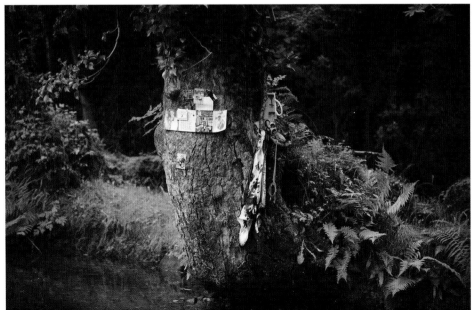

And those who know your name put their trust in you, for you, O Lord, have not forsaken those who seek you. (Ps 9:10)

ST FACHANAN'S WELL *The Burren, County Clare*

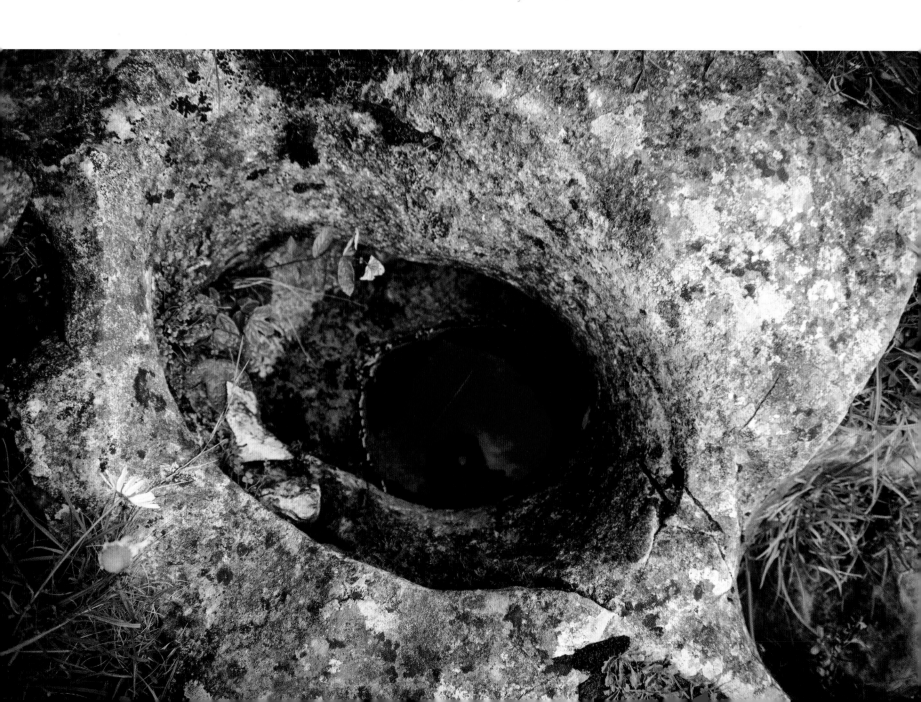

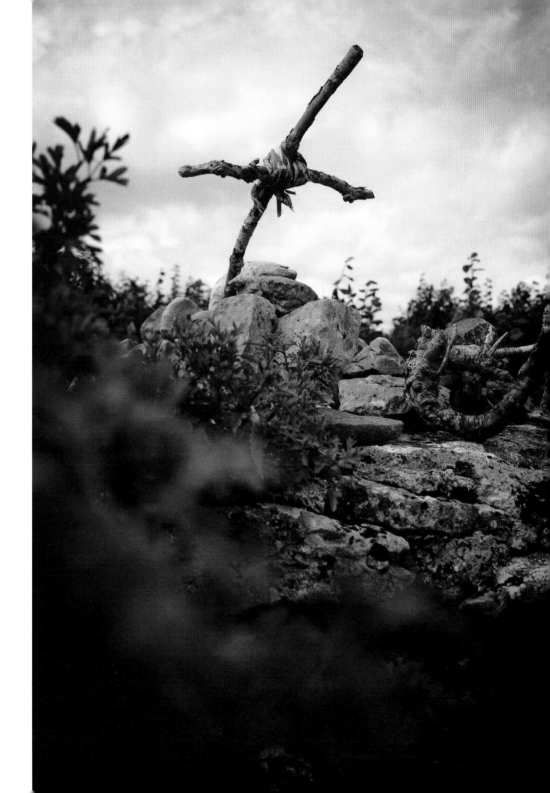

How precious is your steadfast love,
O God! All people may take refuge in
the shadow of your wings. They feast on
the abundance of your house, and you
give them drink from the river of your
delights. For with you is the fountain of
life; in your light we see light.

(Ps 36:7–9)

Some holy wells are like sources of energy from which we can draw nourishment and inspiration. They still resonate with the presence and prayers of those who have visited them through the ages. We also bring our own prayers and presence to these places, enriching them further for those who will come after us.

St Fachanan established an abbey in the Kilfenora area of County Clare in the sixth century. Venerated in the diocese of Kilfenora – now combined with the Galway diocese – little is known about his life.

ST GOBNAIT STATUE *Ballyvourney, County Cork*

Slea Head, County Kerry ST GOBNAIT'S WELL

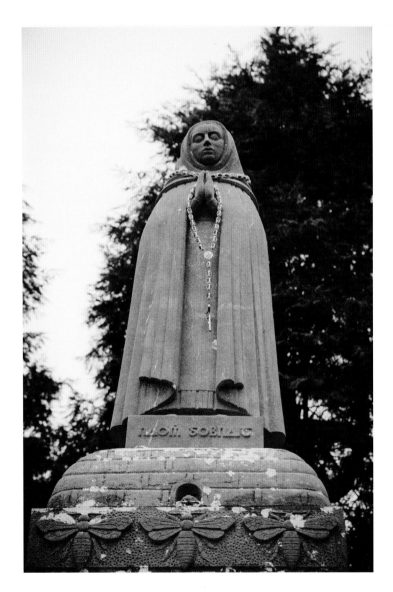

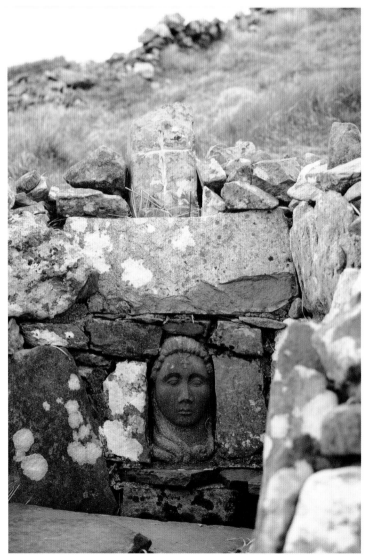

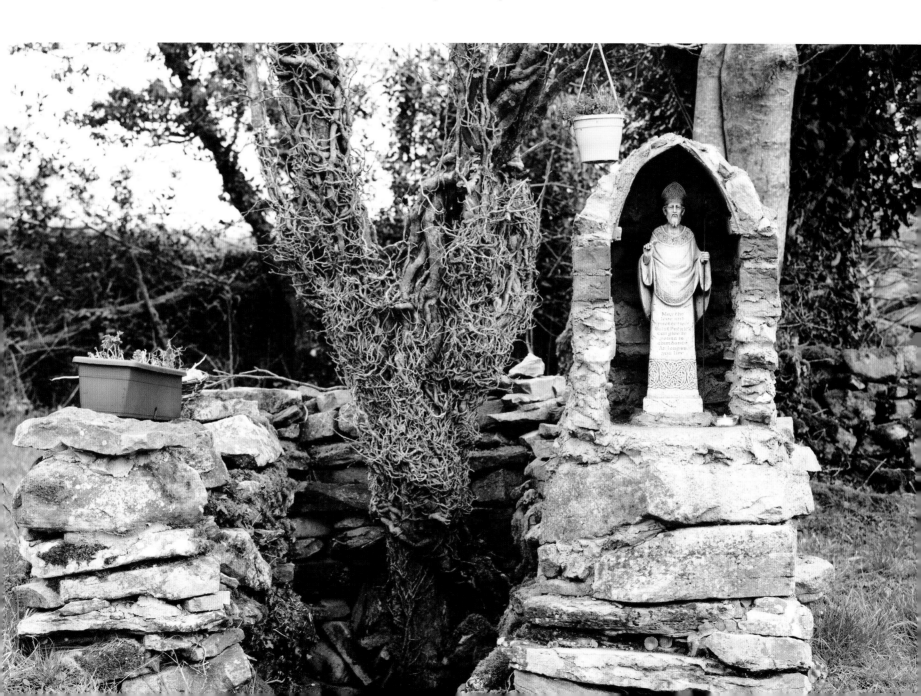

He gives power to the faint and strengthens the powerless. Even youths will faint or grow weary and the young will fall exhausted; but those who wait for the Lord shall renew their strength. They shall mount up with wings like eagles; they shall run and not be weary they shall walk and not faint.

(Is 40:29–31)

This sacred well is dedicated to St Brigid, one of Ireland's three patron saints. Brigid was born in Faughart, near Dundalk, in AD451 and was renowned for gifts of healing and her love of the poor. A younger contemporary of St Patrick, she founded a monastery in Kildare. She is known as Muire na nGael (Mary of the Gael) and is one of Ireland's most famous saints.

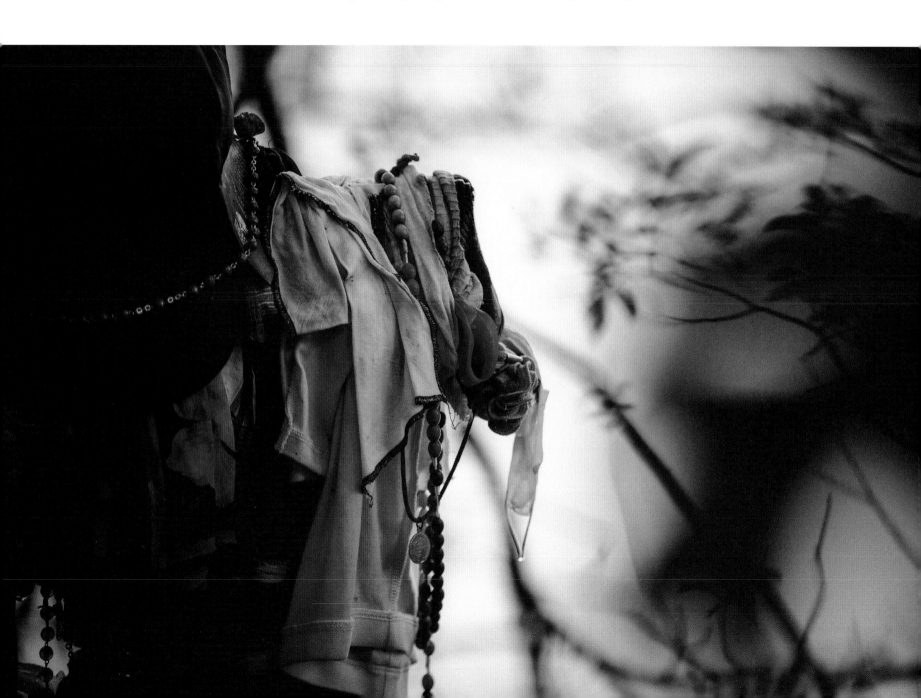

Saint Brigid

Saint Brigid,

you were a woman of peace.

You brought harmony where there was conflict.

You brought light to the darkness.

You brought hope to the downcast.

May the mantle of your peace cover those who are troubled and anxious,

and may peace be firmly rooted in our hearts and in our world.

Inspire us to act justly and to reverence all God has made.

Brigid, you were a voice for the wounded and the weary.

Strengthen what is weak within us.

Calm us into a quietness that heals and listens.

May we grow each day into greater wholeness in mind, body and spirit.

Amen.

Traditional Irish Prayer

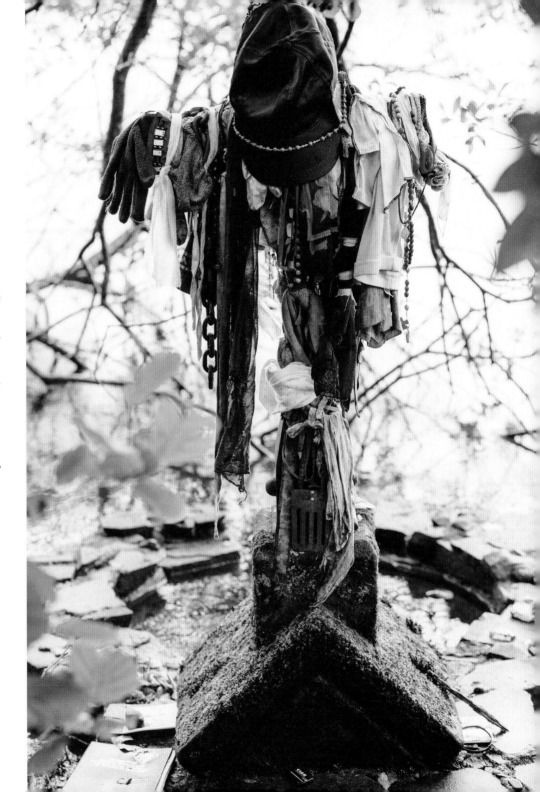

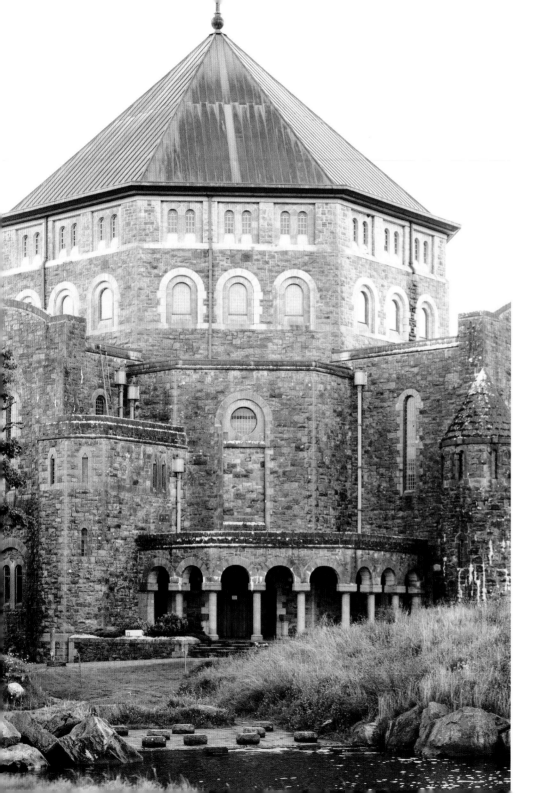

Lough Derg, associated with St Patrick from the fifth century on, has been a place of pilgrimage since at least the twelfth century, when its fame spread thoughout Europe. This penitential island still draws thousands of pilgrims to its shores each year, where they pray, walk barefoot on the cold stones and fast for the duration of their stay.

Left: The Basilica, Lough Derg, County Donegal.
Right: The Cross of Saint Patrick.

THE APPARITION SHRINE *Knock, County Mayo*

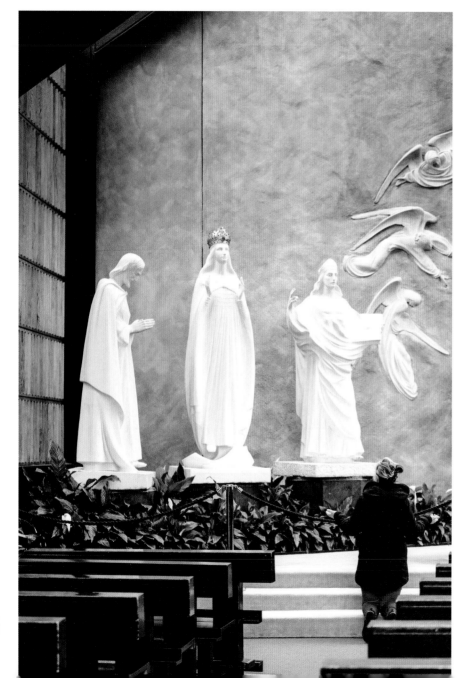

In August 1879, a group of villagers witnessed an apparition at the gable end of the little church in Knock. Our Lady was seen with St Joseph and St John the Evangelist. No words were spoken. Since then, devotion to Our Lady of Knock has grown throughout Ireland and beyond. Knock is now recognised as Ireland's national Marian shrine.

Prayer to Our Lady of Knock

Our Lady of Knock, Queen of Ireland,
you gave hope to your people
in a time of distress and comforted them in
 sorrow. You have inspired countless pilgrims
to pray with confidence to your divine Son, r
emembering his promise,
'Ask and you shall receive,
seek and you shall find'.
Fill me with love for my brothers and sisters in
 Christ.
Comfort me when I am sick, lonely or depressed.
Teach me how to take part ever more reverently
 in the Holy Mass.
Give me a greater love for Jesus in the Blessed
 Sacrament.
Pray for me now and at the hour of my death.
Amen.

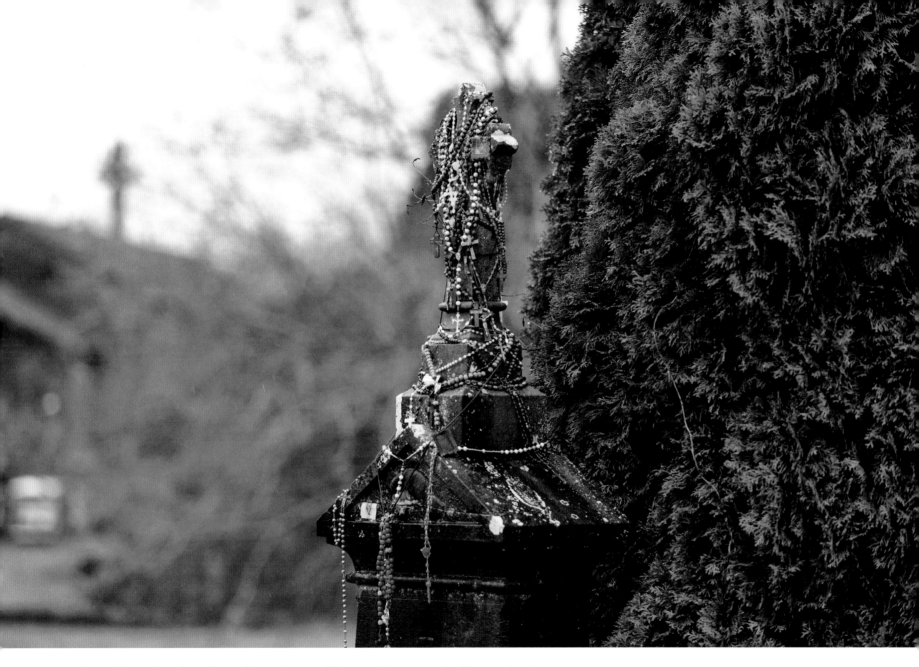

Above: The resting place of one of the witnesses of the apparition, covered with rosary beads.

OUR LADY'S WELL *Portmagee, County Kerry*

Rejoice in hope,
be patient in suffering,
persevere in prayer.
(Rom 12:12)

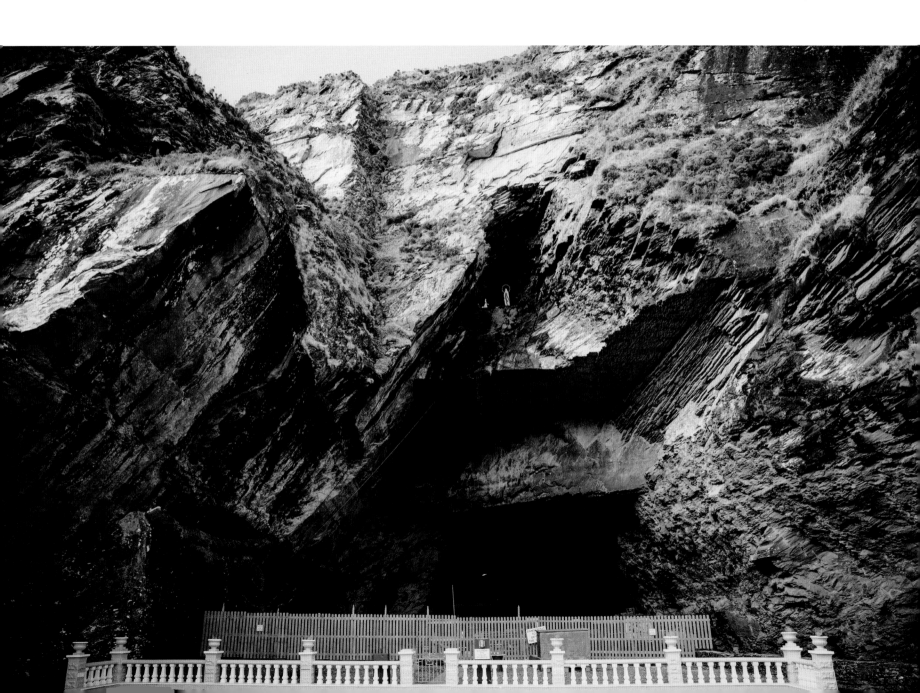

THE ROSARY

For generations, the rosary has nurtured the faith of Irish people, although it sometimes seems that today it is largely reserved for the elderly and for recitation at wakes and funerals. Seldom spoken about, it has become a private prayer, a whispered litany.

By reciting the rosary, we accompany Mary, our model in faith, through the life of her son, Jesus. With her, we reflect on his birth, passion, death and resurrection. Like her, we place our complete trust in God, relying on his strength when our own is failing, believing that God is with us no matter what life brings, and hoping that God will be with us right until the end of our lives. In this way, Mary is our inspiration in faith. She was with Jesus to the end and witnessed the new life of Easter. She is as close to God as anyone could ever hope to be. Mary is our model of faith, open to God's will, saying 'yes' not just once but over and over again. 'Let it be with me according to your Word' (Lk 1:38).

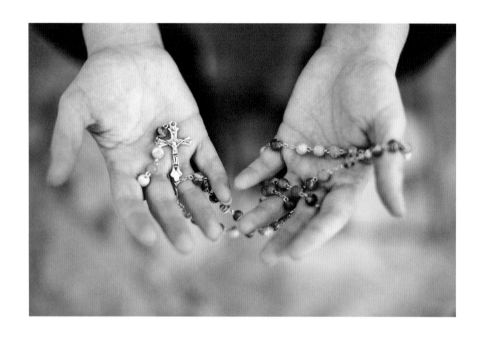

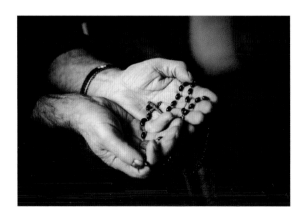

'The rosary is the prayer that always accompanies my life; it is also the prayer of simple people and saints … it is the prayer of my heart.'
Pope Francis, October 2016

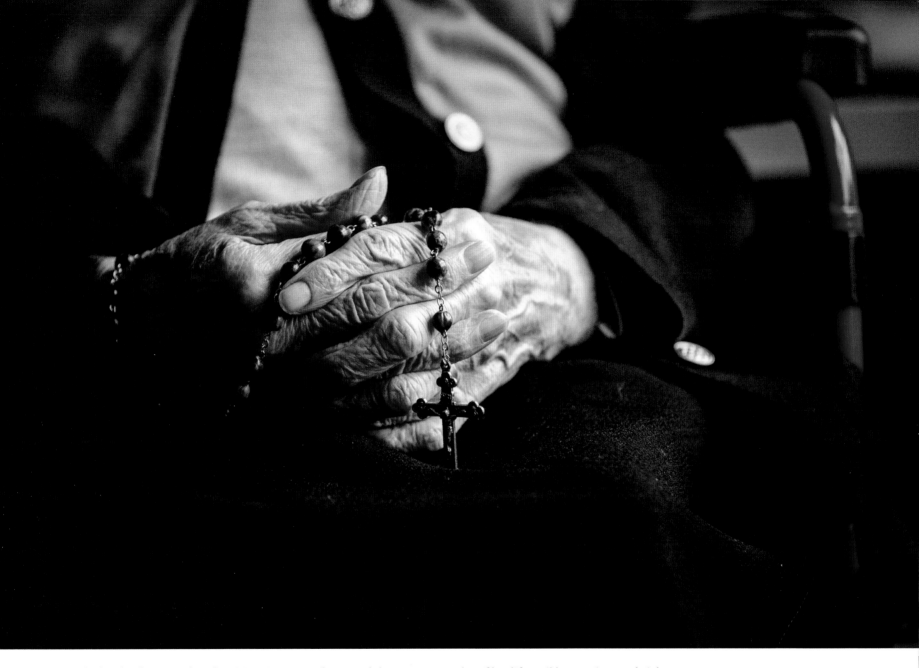

The hands of my grandmother, Mena Bannon, who prayed the rosary every day of her life until her passing aged eighty-seven.

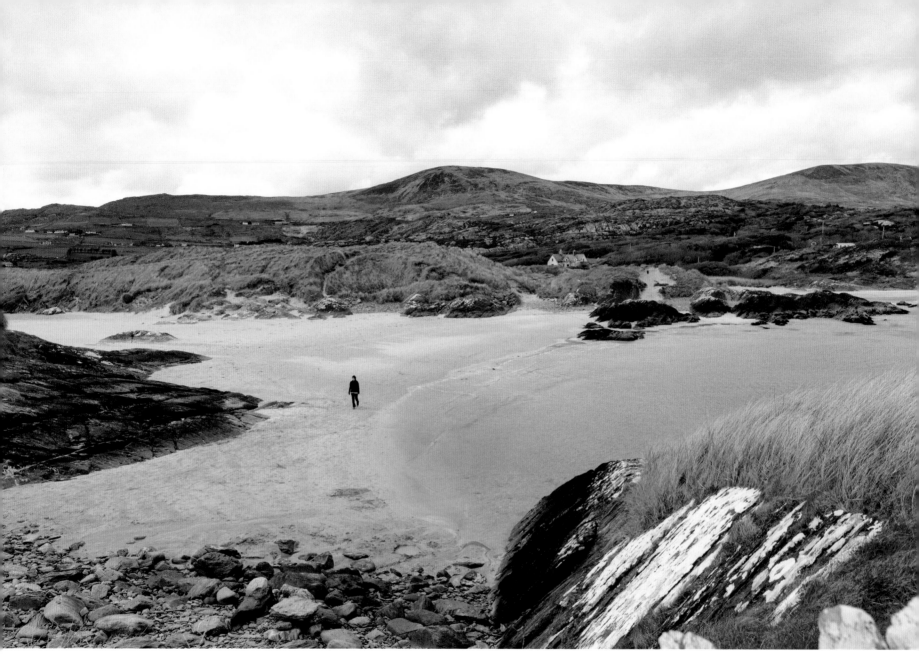

A lone walker on Derrynane Mass Path, County Kerry.

Praying
TODAY

PEOPLE today travel and experience other cultures more easily than was ever possible before. As a consequence, new perspectives on life have opened up, and God's presence can sometimes be felt in unexpected places as well as in the more traditional ones. All of this invites us to look afresh at our inner lives and our inheritance of faith.

So, where do we find God today? Some people feel close to God while digging their back garden, or relaxing in a city park, or sitting in a bus after work or listening to some quiet music on their headphones. Let's take a look at some of the traditional places where people find prayer – and some of the newer ones as well.

Come away to a deserted place all by yourselves and rest a while.
(Mk 6:31)

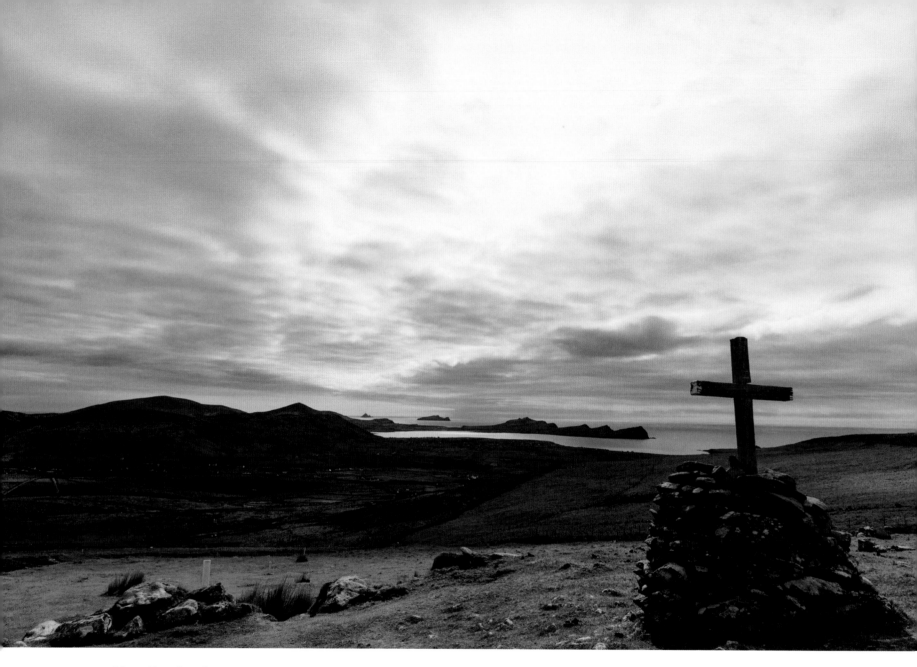

Mount Brandon, County Kerry.

There's something about the sea that touches us deeply. We become more acutely aware of our deeper selves as we listen to the rhythmic roll of the waves and view the vast expanse of the ocean. Certainly, there is something about the seashore that connects me to what is most important for me, to my God who is limitless in his love and mercy. Here I can sense the presence of the God who journeys with me, helping me slowly to glimpse the unfolding mystery of his love and to trust his guidance in my life.

I have let go of many things at the seashore – hurts, fears, resentments – and it has always been a place of great healing for me. And I know that I'm not the only one to experience this. The healing qualities of the sea have long been documented, allowing us to disconnect from our chaotic world, if only for a short time. We don't often value this type of tranquillity, but it can be incredibly restorative for us when our own resources are low and we feel unable to cope.

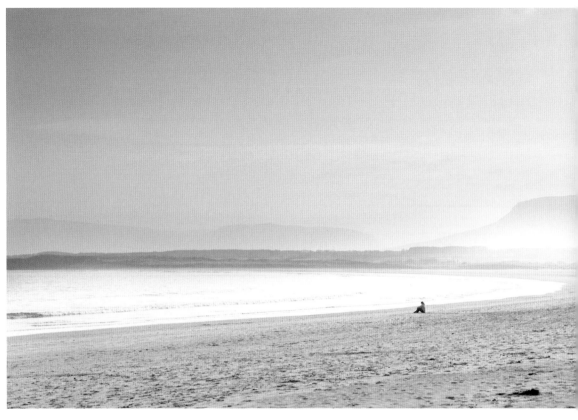

On the beach at Mullaghmore, County Sligo.

Isn't the seashore a reflection of our lives? The shoreline is like the space we inhabit between the great unknown – the mystery of God, heaven and eternal life – and life as we know it, the mundane reality of the here-and-now.

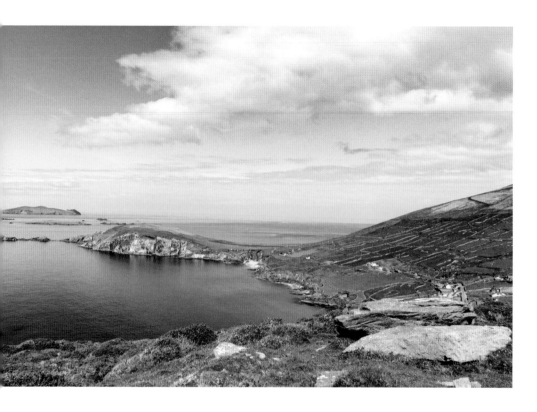

The great sculptor Michelangelo is reputed to have said that any masterpiece he produced was already there before he created it. It was waiting to be discovered, already hidden in a single block of marble. As an artist, his role was to make visible what was hitherto hidden, to give it concrete shape.

God does something like that with us too, shaping the void that exists within into tangible forms. He wants to chisel our lives into pure love, to mould our thoughts into streams of silent listening, to fill our hearts with awe and wonder and to discover the One in whom all this exists. All we need is an artist's eye, a listening ear and humble spirit. It's a gift freely given.

There is a walking path high above the road on Slea Head, in County Kerry, that is magical. It has a rhythm, a melody and a harmony all of its own. It is a world where we come to know God, the generous giver. The outward scene seems to mirror our own inner world, gently beckoning us into the beyond. It is a restful place that yet invites us to explore further. While relishing the present moment, we are drawn into something greater.

Silence here is not an absence of companionship, but an invitation to be grateful for all the love and kindness we have known. A walk like this connects us with something more than ourselves and our thoughts. We come in touch with the longing and the searching of the whole of humanity, and we know intuitively that God is with us – with all of us – as we walk the journey of life, one step at a time.

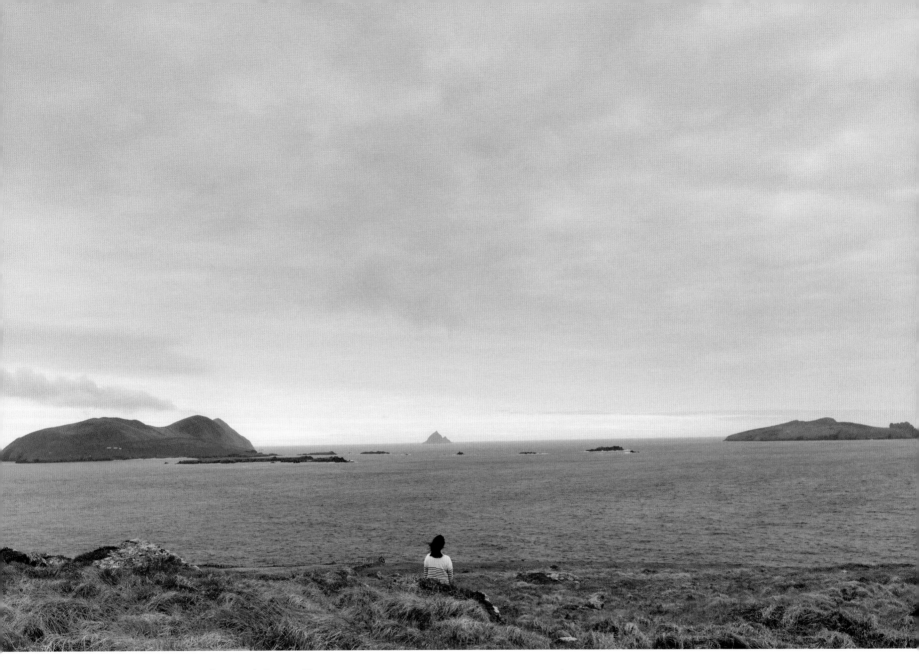

Lost in contemplation at Slea Head, County Kerry.

O Lord, our Sovereign,
how majestic is your name
in all the earth!
When I look at your heaven,
the work of your fingers,
the moon and the stars
you have established,
what are human beings that
you are mindful of them,
mortals that you care for them?
Yet you have made them
a little lower than God,
and crowned them with
glory and honour.
You have given them dominion
over the works of your hands,
you have put all things under their feet,
all sheep and oxen, and also
the beasts of the field,
the birds of the air,
and the fish of the sea,
whatever passes along
the paths of the seas.
O Lord, our Sovereign,
how majestic is your name
in all the earth.

(Ps 8:1, 3–9)

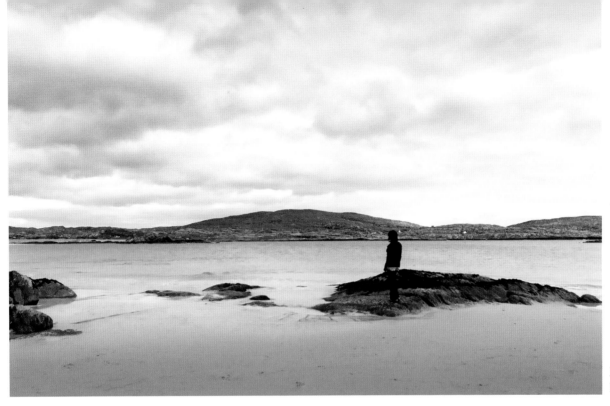

Left: Derrynane, County Kerry.
Facing page: Valentia Island, County Kerry.

Allow your feet to feel the earth
as though for the first time.
The earth is a place of solidity and strength,
gravity and grace in equal measure.
No one like you has walked this place before.

You are chosen and loved,
and God's own hand has made you.
Do not forget that his presence follows you
wherever you go.
Allow your feet to feel the earth
and give yourself the time to savour
even seconds of this miracle.

Do not neglect your own eyes,
your own heart, your own skin.

Walk to the seashore …

… leave your troubles there.

Set down your cares and hand them to the ocean;
The ocean that engulfs and consumes,
The ocean that takes and gives life,
The ocean that is both seeing and unseeing,
The ocean that is only a drop
compared to the expanse of God's love for you.

It is a place of rest, a place of deep grief,
a place of heavy loads and wiped tears,
a place that is unchanging and unending.

God is here.

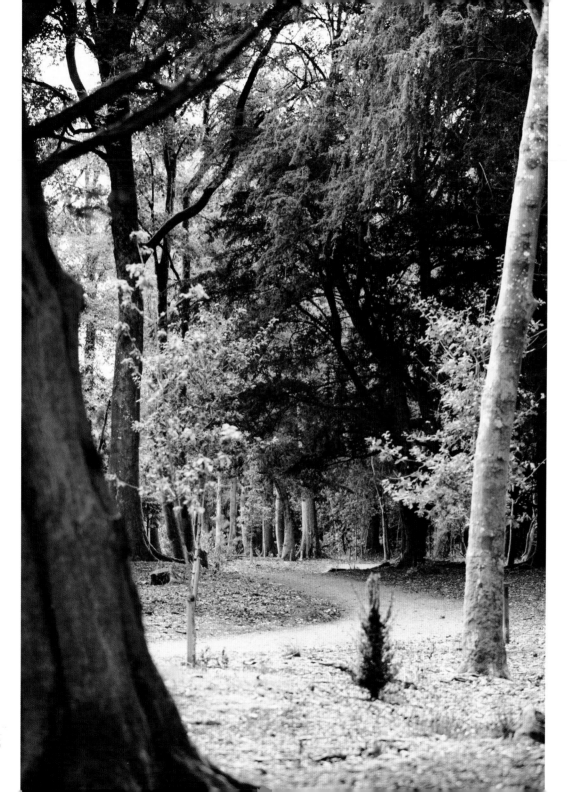

*Let the heavens,
sea and soil
be your friend;
for it is only when we look
with our eyes wide open
that we see the beauty that
the Lord our God has
created for us.*

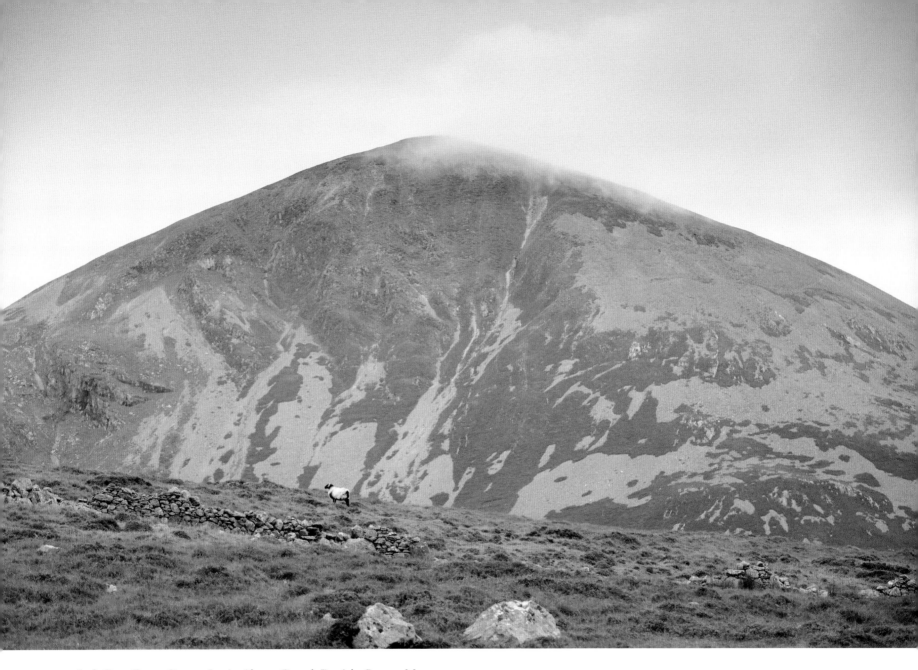

Left: Emo Court, County Laois. Above: Croagh Patrick, County Mayo.

Remember, you're in good company: Moses, Jesus, Patrick. Be present as you climb. Encounter God.

Source: Croagh Patrick Pilgrim Prayer Card

St Finbarr's Way, from Dromoleague to Gougane Barra, County Cork

In Ireland recently, we have rediscovered many of the ancient medieval pilgrim paths, particularly the five major ones: St Kevin's Way (Wicklow), St Finbarr's Pilgrim Path (Cork), Cnoc na dTobar (Kerry), Cosán na Naomh (Kerry) and Tóchar Phádraig (Mayo). Some of these walks are more difficult than others, depending largely on the terrain, and they are undertaken by all sorts of people – men and women, young and old, people of faith and those with none.

All of these people, I believe, find themselves enriched by the experience, and many find God. A fragile sparrow, a field of corn, a beautiful sunset: these can bring peace to a troubled heart, and a hint of God's presence. I sometimes find prayer as I look at the stones on the road or the path stretching ahead, or as I listen to the sound of feet on gravel. As I get into the rhythm of the walk, I find that there

is no distinction between myself and the walk; we become as one. My prayer can often be as simple as, 'My God, I thank you for my life'. It can be as profound as that as well.

These ancient roads and pathways still breathe life between their hedges and stone walls. Our ancestors walked these routes for many reasons: in repentance, in search of healing, in thanksgiving and sometimes just to be where a holy man or woman once lived. They relished the experience.

It is enough simply to live the experience. 'Let your breathing in and out be your prayer to and from such a living and utterly shared God. You will not need to prove it, nor can you, to anybody else. Just keep breathing with full consciousness and without resistance, and you will know what you need to know.'[6]

6. Richard Rohr, *Things hidden: Scripture as Spirituality*, (Cincinnati: St Anthony Messenger Press, 2008).

In the Judeo-Christian tradition, the word creation has a broader meaning than nature,
for it has to do with God's loving plan in which every creature has its own value and significance.
Nature is usually seen as a system which can be studied, understood and controlled,
whereas creation can only be understood as a gift from the outstretched hand of the Father of all,
and as a reality illuminated by the love which calls us together into universal communion.

Pope Francis, *Laudato Si'*, para. 76

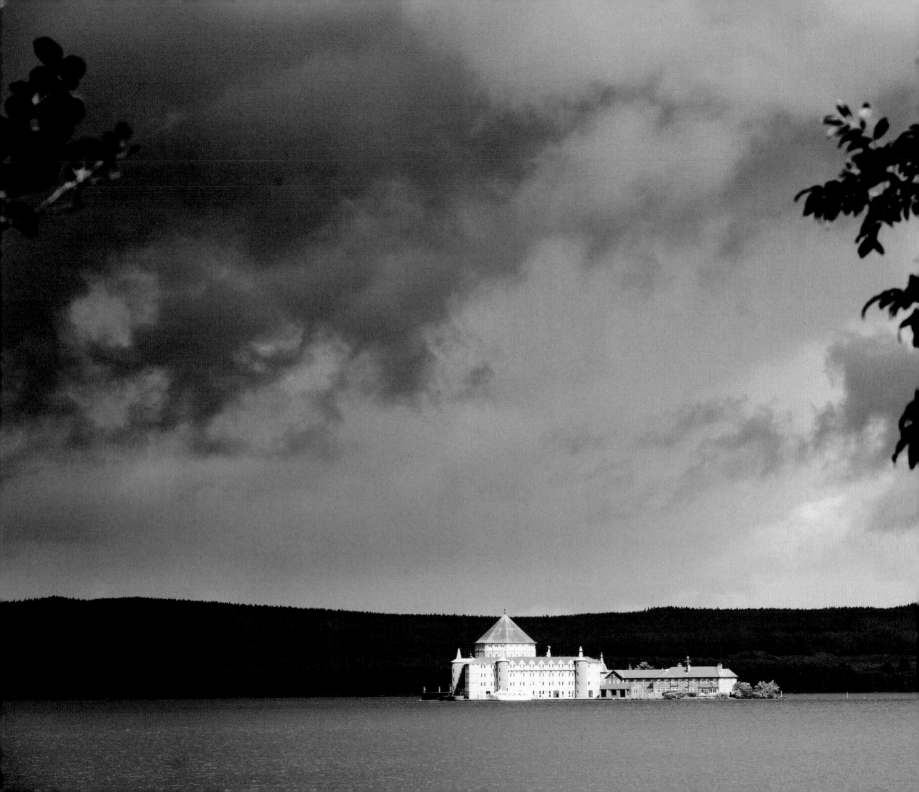

St Patrick's Breastplate

I arise today, through the strength of heaven;
light of the sun, splendour of fire, speed of lightning,
swiftness of the wind, depth of the sea,
stability of the earth, firmness of the rock.
I arise today, through God's strength to pilot me,
God's might to uphold me, God's wisdom to guide me,
God's eye to look before me, God's ear to hear me,
God's Word to speak for me, God's hand to guard me,
God's way to lie before me, God's shield to protect me,
God's hosts to save me, afar and near, alone or in a multitude.
Christ shield me today against wounding.

Christ with me,
Christ before me,
Christ behind me,
Christ in me,
Christ beneath me,
Christ above me,
Christ on my right,
Christ on my left,
Christ when I lie down,
Christ when I sit down,
Christ in the heart of everyone who thinks of me,
Christ in the mouth of everyone who speaks of me,
Christ in the eye that sees me, Christ in the ear that hears me.
I arise today, through the mighty strength of the Lord of creation.

Station Island, Lough Derg, County Donegal.

Above and facing page: Peace Garden and Retreat House, Mullaghmore, County Sligo.

Jesus came and stood among them and said, 'Peace be with you'. After he said this he showed them his hands and his side. Then the disciples rejoice when they saw the Lord. Jesus said to them again, 'Peace be with you.' (Jn 20:19–20)

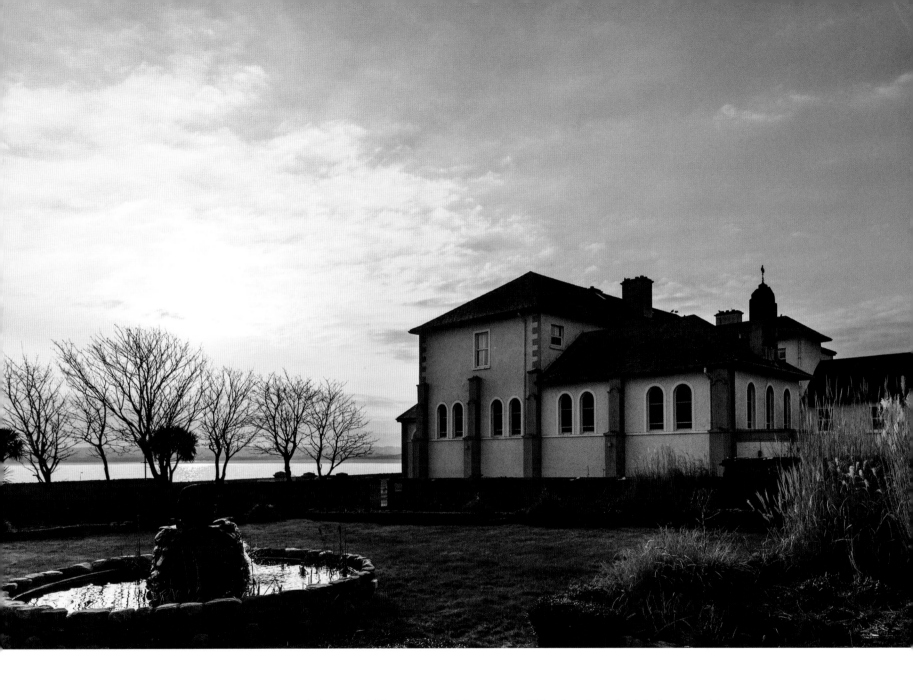

The Lord bless you and keep you; The Lord make his face to shine upon you and be gracious to you; The Lord lift up his countenance upon you and give you peace. (Num 6:24–26)

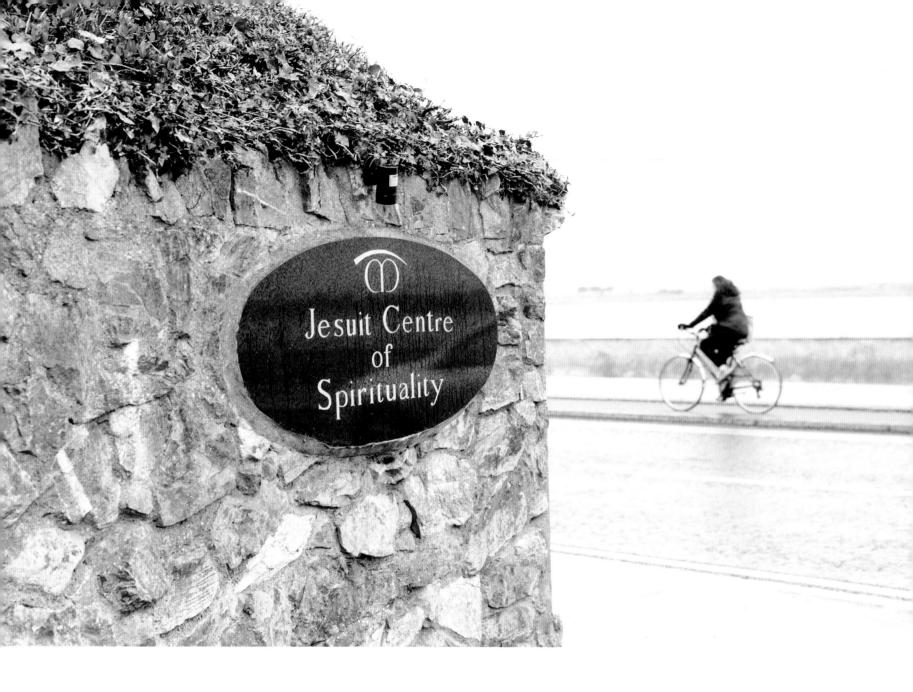

Manresa, Jesuit Centre of Spirituality, Dollymount, County Dublin.

Close to the heart of Dublin, Manresa is yet a place apart, an ideal spot in which to nourish the spirit and find peace in God. In a tranquil setting by the sea, Manresa offers a range of programmes rooted in the Ignatian tradition: retreats of all kinds, one-to-one accompaniment, training in spiritual direction, programmes for the deepening of faith and prayer and seminars on a wide range of topics.

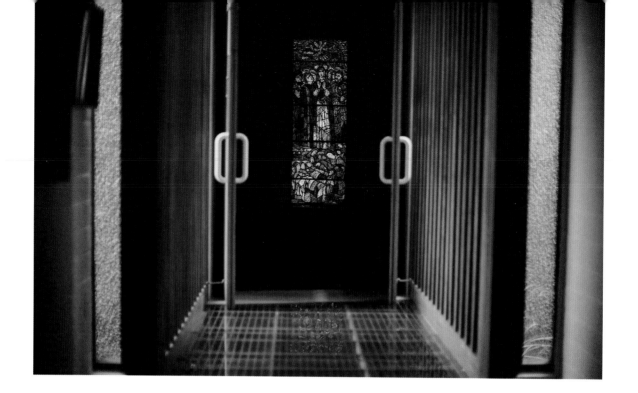

Top of facing page: the entrance to the prayer room at Manresa. Above and facing page, the spacious grounds.

The closer one approaches to God, the simpler one becomes. St Teresa of Avila

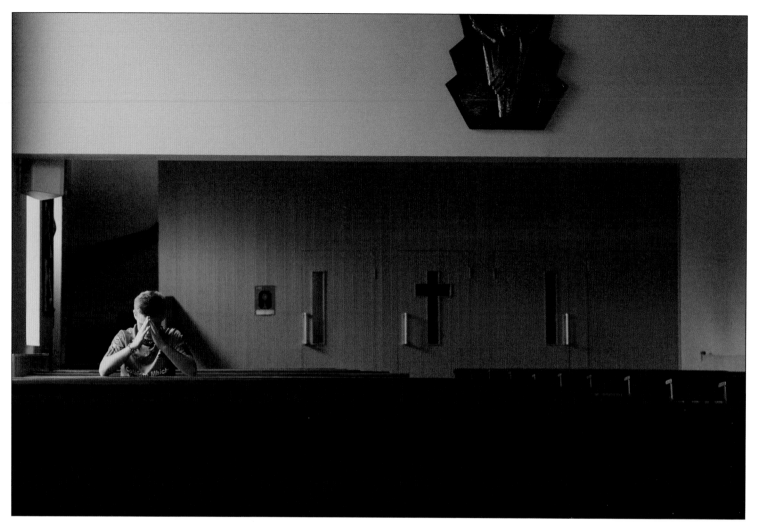

Church of St Malachy, Ballymacilroy, County Tyrone.

Ask and it will be given to you; seek and you will find; knock and the door will be opened to you. For everyone who asks, receives; and the one who seeks, finds; and to the one who knocks, the door will be opened. (Mt 7:7–9)

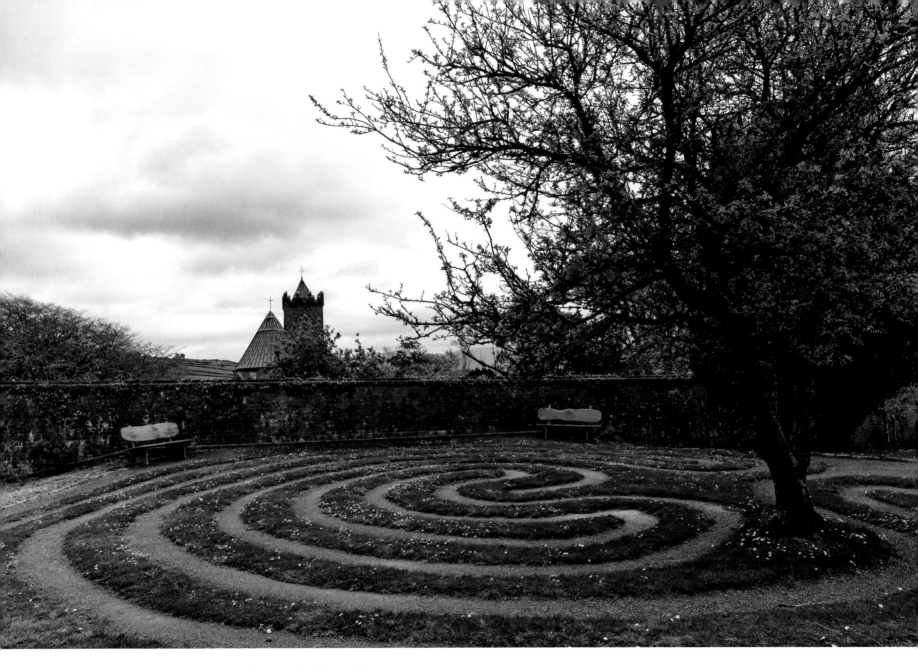

Labyrinth, An Díseart Prayer Garden, Dingle, County Kerry.

Within our communities and towns, places of prayer are no longer confined
to the church or in the home. You will find prayer gardens and gardens for
reflection in many parts of the country today. You can visit these and can
stay as long as you wish, enjoying the peace and harmony of creation.

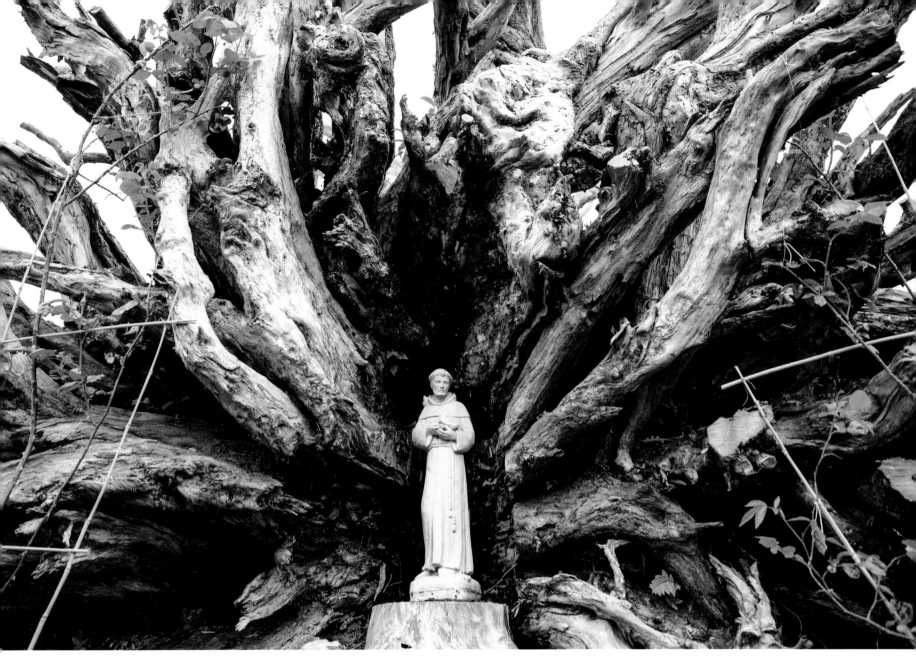

Above and facing page: Franciscan Friary Gardens, Killarney, County Kerry.

Any place that allows you to take time away from the hassle of daily living and come close to God is a prayerful place for you. In this prayerful place, you are set free to express to God your inmost thoughts and concerns, and to hear God's whispered, loving response. Find opportunities, if you can, to connect with God each day, if only for a few moments. This awareness of God's presence will then overflow into your ordinary living, allowing God's gift of peace to grow in you. This growth is largely imperceptible, like the growth of a great tree, but God is at work all the time. A prayerful place is any place that enables you to find God in the noisy world we inhabit daily.

How we pray in today's world can sometimes be surprisingly different from the ways our ancestors prayed, but the opportunities to pause, reflect and pray are still there if we make the effort. Some people like to create a special place in their homes that they set aside for prayer – a small table or quiet corner that resonates for them with God's presence. Others like to light a candle or use a picture to help them recall God's presence. And, of course, a favourite passage from scripture or from a spiritual writer can help us reach a place of prayer within ourselves.

Some people find time to pray in their car, or on the bus, or even standing in a queue. The few minutes after the TV has been turned off in the evening can be an opportunity for restful prayer. And today's technology means that we can now pray in ways we never thought of before – in front of a computer screen, with the help of websites like Sacred Space, or by downloading apps like Pray as You Go on a mobile device. Even in today's busy world, opportunities for prayer are many.

These days in Ireland, many people are searching for answers to the great questions of life. With all the pressures of today's world, there is a growing hunger for authentic living and a continual struggle to find a way to live in peace. All of this takes time, of course. Growth is part of life, and all growth is slow and demands perseverance. Prayer is like a pilgrimage: it means taking one step at a time, even if the going is rough occasionally. As we persevere, however, the wonders of the journey unfold. Then we will be able to relish the present moment but also discover a future that God alone can offer.

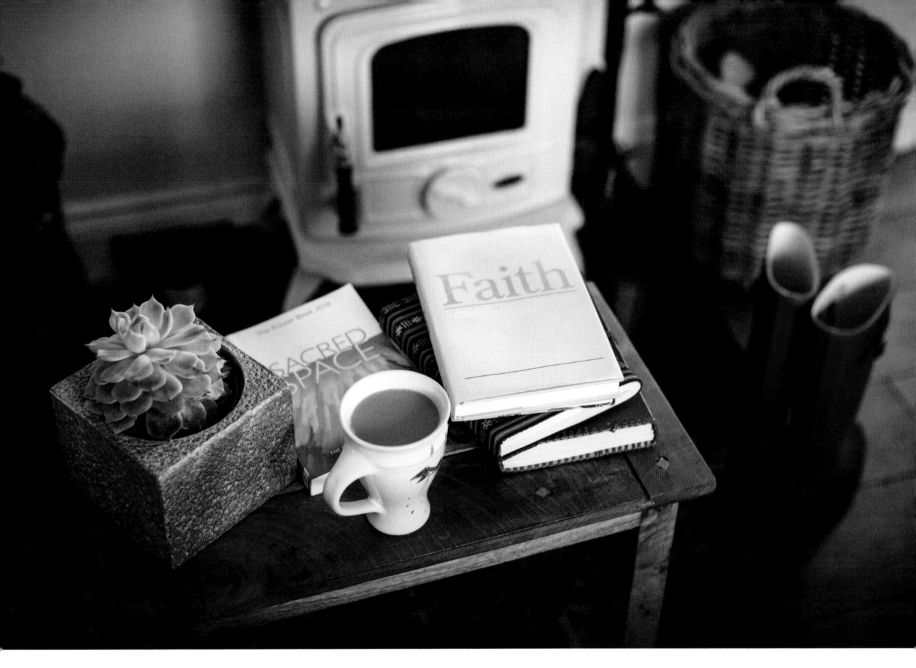

Prayer can happen anywhere: in the car, at the dinner table, quiet moments of gratitude, while we work…

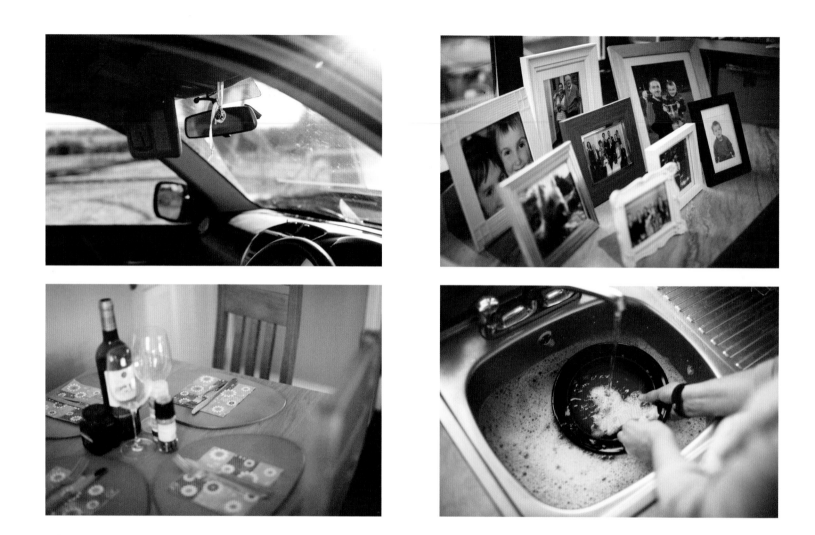

God is everywhere, and can be found wherever we happen to be, if we only open our eyes.
God is not confined, and so there is no right or wrong place to seek God. We are sometimes drawn to
places that have a special resonance about them, places where the presence of God is tangible,
like the Holy Land or Lourdes. But God can also be found in your back garden or in your sitting room.